BOGGS

BOOKS BY LAWRENCE WESCHLER

— —

The Passions and Wonders Series

Seeing Is Forgetting the Name of the Thing One Sees:
A Life of Contemporary Artist Robert Irwin

David Hockney's Cameraworks

Mr. Wilson's Cabinet of Wonder

A Wanderer in a Perfect City: Selected Passion Pieces

Boggs: A Comedy of Values

— —

Political Reportage

The Passion of Poland

A Miracle, A Universe: Settling Accounts with Torturers

Calamities of Exile: Three Nonfiction Novellas

BOGGS

A Comedy of Values

Lawrence Weschler

THE UNIVERSITY OF CHICAGO PRESS · CHICAGO AND LONDON

LAWRENCE WESCHLER, a staff writer at the *New Yorker* since 1981 and a recip-
ient of the prestigious Lannan Literary Award for 1998, is the author of nu-
merous previous books, including *Calamities of Exile: Three Nonfiction Novellas*,
published by the University of Chicago Press, and *Mr. Wilson's Cabinet of Won-
der*, which was a finalist for both the Pulitzer Prize and the National Book
Critics Circle Award.

The University of Chicago Press, Chicago 60637
The University of Chicago Press, Ltd., London
© 1999 by Lawrence Weschler
All rights reserved. Published 1999
08 07 06 05 04 03 02 01 00 99 1 2 3 4 5

Portions of this book originally appeared, in somewhat different form, in the
New Yorker.

ISBN: 0-226-89395-2 (CLOTH)

Library of Congress Cataloging-in-Publication Data

Weschler, Lawrence.
 Boggs : a comedy of values / Lawrence Weschler.
 p. cm.
 Includes bibliographical references and index.
 ISBN 0-226-89395-2 (cloth : alk. paper)
 1. Boggs, J. S. G. (James Stephen George) 2. Paper money.
 3. Money in art. 4. Value. I. Title.
 HG353.W47 1999
 332.4—dc21 98-53267
 CIP

♾ The paper used in this publication meets the minimum requirements of
the American National Standard for Information Sciences—Permanence of
Paper for Printed Library Materials, ANSI Z39.48-1992.

CONTENTS

Boggs's self-portrait on his rendition of a Swiss one-hundred-franc bill

BANQUE NATIONALE SUISSE
BANCA NAZIONALE SVIZZERA ✚

PREFACE

ES, A COMEDY. But then, again, maybe not so funny after all. At any rate, it sure can give one pause the way such serious, even scary, stakes keep getting dragged into play by the antics of our sly protagonist, the perpetually confounding money artist, J. S. G. Boggs.

What else is one to make, for example, of the recent headlines to the effect that the stocks of all of America's banking and financial institutions—the issues, that is, of such staid entities as Citicorp and BankAmerica and Merrill Lynch—themselves managed to shed over $350 billion dollars in value

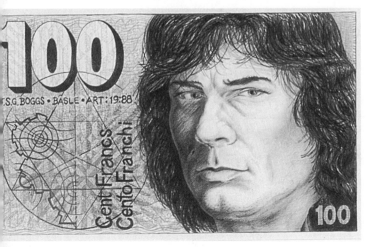

in just a few dreadful months of international economic tur-
moil?[1] Three hundred and fifty *billion* dollars—*gone*. Like
that. But where? Into thin air, of course, as the commentators
kept marveling, dumbfounded.

Into that very same thin air, that is, out of which Boggs
himself keeps conjuring his mysterious store of value, and
upon which he keeps staking his disconcerting brace of
claims.

A good moment, then, to return for a fresh look at J. S. G.
Boggs's subversive merrymaking. Back in 1987–88, when I
first began tracking the activities of this Til Eulenspiegel of
the art and money markets, both of those soaring markets had
likewise just come plunging scarily back to earth.[2] Granted,
things seemed to stabilize—sorta, kinda—across the decade
thereafter (considerably more so for the financial than for the
art markets). But here we now find ourselves all over again,
with everything we'd once again taken to taking for granted
suddenly getting taken away—taken, that is, to the very place
where, it turns out, Boggs has been tarrying (tinkering, pon-
dering, noodling) the entire while. With value itself suddenly
coming up for grabs. And Up-for-Grabs turning out to be the
very place where Boggs *lives*.

1. Or the parallel stories about those two Nobel Prize–winning economists, hon-
ored a few years back for their brilliant work in elaborating excruciatingly complex
formulas for determining the precise true value of variously arcane financial instru-
ments, who, in turning around to put those theories into practice with the now-noto-
rious Long-term Capital Management hedge fund, somehow managed to end up
jeopardizing over a trillion dollars in other people's compounding, cantilevered in-
vestments. Makes one wonder, at very least, about the precise true value of the Nobel
Prize. (See "When Theory Met Reality: Teachings of Nobelists Also Proved Their
Undoing" on the front page of the November 14, 1998, *New York Times*.)

2. The first portion of this current volume originally appeared as a two-part pro-
file in the January 18 and 25, 1988, issues of the *New Yorker* and was then included in
my now out-of-print collection, *Shapinsky's Karma, Boggs's Bills, and Other True-Life
Tales*, North Point Press, 1988. (The five other pieces from that collection have in the
meantime, in turn, formed the core of a new, expanded collection of my "selected pas-
sion pieces," *A Wanderer in the Perfect City*, Hungry Mind Press, 1998.) This current
volume consists of a modest expansion of that original North Point material, along
with a substantial amount of new writing bringing the story up to date.

No wonder treasury police all over the world can't seem to leave the poor devil alone.

— —

I'm reminded of one of Boggs's soulmates, another old subject of mine, an at-that-time Yugoslav performance artist named Tomislav Gotovac who used to like stripping stark naked and parading about, his arms stretched proud and wide, through the quaint, cobblestoned streets and squares of his native Zagreb—the art consisting both of that patently loaded gesture all by itself (this solitary individual, naked before the power of a totalitarian mass state) and of all the complications the gesture invariably provoked. Once, dragged before a bank of dour judges, Gotovac endeavored to defend himself: "You don't seem to understand, your honors; you see, I'm an artist and my metier consists in stripping naked and parading through city streets." Whereupon the head judge calmly interrupted him, "No, no, it's you, Mr. Gotovac, who doesn't seem to understand; for, you see, we are judges and our metier consists in throwing you in jail."[3]

Boggs puts me in mind of several others of my subjects as well, perhaps none more so than that deadpan-wry provocateur, David Wilson, the founding director of the Museum of Jurassic Technology in Los Angeles. The title character of my 1995 book, *Mr. Wilson's Cabinet of Wonder* (composed, as it were, between the two flanks of this current volume), Wilson, over the past several years, has in effect been doing for museums—and the authority of museums—what Boggs has been doing for money and the authority of money. Which is to say, with the one as with the other, you never can be quite sure where you stand, or are supposed to stand; there's always this slight sense of slippage.

Consider, for example, the Cameroonian stink ant, the subject of one of the most unsettling of the diorama vitrines at Wilson's museum. According to the caption and the accom-

3. "Exhibition" in the *New Yorker* ("Talk of the Town"), January 14, 1991.

panying acoustiguide—but, again, who's to say?—the stink
ants form an exceptionally industrious tribe of insects, me-
thodically scavenging for food across the West African rain
forest floor. But every once in a while, one of their number
will accidentally inhale a microscopic fungal spore drifting
down from somewhere in the canopy above. The spore quickly
lodges in the poor mite's brain, and, stupefied, the creature
staggers off, confounded, bewildered, confused. Presently—
and for the first time in its life—the ant leaves the rain forest
floor, scaling the tendrils of nearby hanging vines, climbing
unaccountably higher and higher until it reaches a certain
prescribed height, at which point it impales its mandibles on
the vine stalk and waits to die. Within days of that death, a
spikelike prong suddenly erupts from out of what had once
been the creature's forehead, its orange tip heavy laden with
microscopic fungal spores which now rain down upon the rain
forest floor for other unsuspecting ants to inhale.

I once asked David Wilson what had first drawn him to the
ant's bizarre saga (which, incidentally, turns out to be entirely
true, more or less),[4] and after noting how the creature's life
cycle provided a singularly remarkable instance of the natural
phenomenon of symbiosis, a subject in which he'd long har-
bored an interest, Wilson went on to suggest that what had
really floored him when he'd first heard about it were the
metaphorical implications of the stink ant's fate, the way its
story seemed to double, as it were, as a metaphor for his very
own life. He could identify with that ant, he told me: he too
felt like he'd inhaled a spore a long while back, staggering
around for some time thereafter—"impelled, as if possessed,
to do things that defied all common sense"—before finally
alighting on this, his current vocation, running this little
storefront museum, and, in effect, shedding spores for other
unsuspecting visitors to inhale.

What struck *me* as so remarkable about that conversation,
at the time, was the way Wilson's sense of doubling in turn

4. For a photograph of the poor creature in the wild, its forehead gloriously ram-
pant, see *Mr. Wilson's Cabinet of Wonder* (Pantheon/Vintage), p. 69.

dovetailed with the life stories of so many of the other sub-
jects about whom I'd been writing over the previous decade—
and, of course, especially that of my pal Boggs, a spore-inhaling
spore-shedder if ever there was one. Now, Boggs's metier, as
I've suggested, is money—money in all its manifold, con-
founding complications. Money, for that matter (as it recently
occurred to me), as itself a spore-inhaling spore-shedder from
way back.[5] Money, in short, as *value*—but then, as Boggs in-
sists on asking over and over again, in all sorts of hilariously
profound and profoundly hilarious ways, what the hell is *that*?

The obstinacy of Boggs's perplex in turn reminds me of
another of my earlier subjects—in this case, Robert Irwin, the
perceptual artist and protagonist of my very first book (1982),
which concluded with a passage that might equally well serve
as a prologue to this one, for Boggs, like Irwin before him, "is
a master of irony and a devotee of serious play. He has an ex-
traordinary tolerance for ambiguity: he asks questions that
seem by their very nature unanswerable, but he maintains his
interest because the questions are legitimate—and are them-
selves probably more interesting than any answer they might
summon. In short, he is an artist who one day got hooked on
his own curiosity and decided to live it."[6]

— —

As the reader will have gathered, I myself got hooked on
Boggs early on, and, for his part, he has had the sweet for-
bearance to put up with it—and for that, first and foremost, I
need to acknowledge and thank him. (He has also been won-
derfully generous in helping provide imagery for the current
edition.)

Over the years, several editors have helped nurse this pe-
culiar obsession of mine along—John Bennet and Pat Crow at

5. Something the Swiss, for their part, seem intuitively to have grasped. See the
image on p. 19 below.

6. *Seeing is Forgetting the Name of the Thing One Sees* (University of California
Press, 1982), p. 203.

Robert Gottlieb's *New Yorker*, Jack Shoemaker and Tom Christensen at the late lamented North Point Press, and now the wry and seemingly unfazable Alan Thomas at the University of Chicago Press. My appreciation goes out to all of them, as it does to the checking department at the *New Yorker*, to Jo Anne Brooks in Boggs's Archive in Florida, to Jill Shimabukuro (this volume's unflappably elegant designer), and Randy Petilos (Alan Thomas's truly unfazable editorial assistant), as well as to my dear and ever-steadfast agent Deborah Karl.

Finally I want to acknowledge the—admittedly at times bemused, vaguely dubious—support and loyalty of my priceless bride Joasia (who in the course of this project has often had to put up with silliness beyond measure) and of our dear daughter Sara (almost exactly the same age, I suddenly realize, as my acquaintance with Boggs), our fond household's very own little perpetual comedy of values.

BOGGS

A Boggs hundred

A FOOL'S QUESTIONS

[1987]

J. S. G. BOGGS is a young artist with a certain flair, a certain panache, a certain *je ne payes pas*. What he likes to do, for example, is to invite you out to dinner at some fancy restaurant, to run up a tab of, say, eighty-seven dollars, and then, while sipping coffee after dessert, to reach into his satchel and pull out a drawing he's already been working on for several hours before the meal. The drawing, on a small sheet of high-quality paper, might consist, in this instance, of

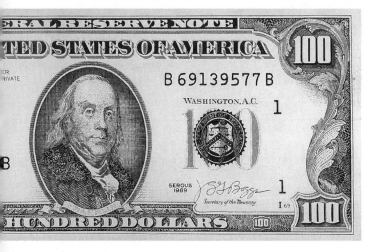

a virtually perfect rendition of the face-side of a one-hun-
dred-dollar bill. He then pulls out a couple of precision pens
from his satchel—one green ink, the other black—and pro-
ceeds to apply the finishing touches to his drawing. This ac-
tivity invariably causes a stir. Guests at neighboring tables
crane their necks. Passing waiters stop to gawk. The maître d'
eventually drifts over, stares for a while, and then praises the
young man on the excellence of his art. "That's good," says
Boggs, "I'm glad you like this drawing, because I intend to use
it as payment for our meal."

At this point, a vertiginous chill descends upon the room—
or, more precisely, upon the maître d'. He blanches. You can
see his mind reeling ("Oh no, not another nutcase") as he be-
gins to plot strategy. (Should he call the police? How is he
going to avoid a scene?) But Boggs almost immediately reestab-
lishes a measure of equilibrium by reaching into his satchel,
pulling out a real hundred-dollar bill—indeed, the model for
the very drawing he's just completed—and saying, "Of course,
if you want you can take this regular hundred-dollar bill in-
stead." Color is already returning to the maître d's face. "But,
as you can see," Boggs continues, "I'm an artist, and I drew
this, it took me many hours to do it, and it's certainly worth
something. I'm assigning it an arbitrary price that just hap-
pens to coincide with its face value—one hundred dollars.
That means, if you do decide to accept it as full payment for
our meal, you're going to have to give me thirteen dollars in
change. So you have to make up your mind whether you think
this piece of art is worth more or less than this regular one-
hundred-dollar bill. It's entirely up to you." Boggs smiles, and
once again, the maître d' blanches, because now he's into *serious*
vertigo: the free fall of worth and values.

Boggs has performed variations on this experiment at
restaurants, hotels, airline ticket counters, hot dog stands,
hardware stores, and countless other venues, in the United
States, England, Germany, France, Ireland, Belgium, Switzer-
land, and Italy. (Although American, he has been based in
London since 1980). He has drawn larger and smaller denom-

inations in each of the local currencies, and he has drawn more and less hostile reactions from each of the local citizenries. Often the maître d's and the cabdrivers and the shopkeepers have rejected his offer out of hand. But during the last two years, Boggs has managed to gain acceptance for his proposal on almost seven hundred separate occasions, in transactions totaling over $35,000 in value.

The entire game, of course, rests on the precision of Boggs's draftsmanship, which is remarkable, and yet Boggs always goes to great lengths to make sure that his victims—his beneficiaries, his patrons, his counterparts (one is not sure quite what to call them)—understand that he is not attempting to foist his drawings off as legal tender. For one thing, they're drawn on only one side of the paper—the other side is left blank, except for Boggs's signature and documentation. And in any case, good as they are, one couldn't actually mistake them for the real thing. Not, that is, unless one happened to be the Bank of England.

One evening in the fall of 1986, just before the opening of a London show that was to feature samples of Boggs's art, three constables raided the gallery, confiscated the work, and hauled Boggs off to jail. He was eventually released into the custody of his solicitor, but dozens of his drawings remain in the custody of the British legal system—Boggs now refers to these as "the Scotland Yard Collection"—and on November twenty-third of this year, in the Central Criminal Court building in London, better known as the Old Bailey, Boggs would be going on trial, charged under Section 18, Subsection I, of the 1981 Forgery and Counterfeiting Act, with four counts of reproducing British currency without the consent of the Bank of England.

Some saw the looming court battle as high comedy, some as low farce, some discerned a question of principle (indeed, nothing short of artistic freedom itself). Some were calling this case the art world's equivalent of the *Spycatcher* scandal. Boggs himself had at varying times seen his situation in all of these lights, but he also saw something else—his life on the

line, for *each* of those four counts, he'd been told, carried a maximum penalty of a ten-thousand-pound fine and ten years in jail.

— —

If the Bank of England intended to exercise some sort of chilling effect upon Boggs's enthusiasms, however, they clearly failed. Despite the trauma of his arrest and the spectre of his coming trial, Boggs continued to pursue his performance investigations with undiminished passion throughout the past year. Some of the results of this curious inquiry were on view this summer at the Jeffrey Neale Gallery on Lafayette Street in the Noho district of New York City. Viewers of this, the thirty-two-year-old artist's first one-man show in New York, were quickly given to understand that as far as Boggs is concerned, the actual drawings of his various bills should merely be considered small parts—the catalysts, as it were—of his true art, which actually consists of the series of transactions they provoke. Thus, in each instance, the framed drawing of the money was surrounded by several other framed objects, including a receipt, the change (each bill signed and dated by Boggs, each coin scratched in with Boggs's initials), and perhaps some other residue of the transaction (for example, evidence of the item purchased—the cardboard carton from a six-pack of beer, a ticket stub for airline travel—or else a photo of Boggs actually handing some swank waiter his drawing and getting back his change, the very change preserved behind glass in the adjoining frame).

One piece, entitled *The Shirts off My Back*, consisted of Boggs's drawing of a one-hundred-Swiss-franc note, the four shirts he was able to purchase with it, and the receipts and change from the transaction. (All of them together were now being offered for sale at $2,000.) Another, entitled *Buying Money* consisted of four miniature coins (a miniquarter, two mininickels, and a minipenny) that Boggs was able to purchase from Florida artist Steve Holm with his own drawing of a one-dollar bill (also displayed), and the two real quarters,

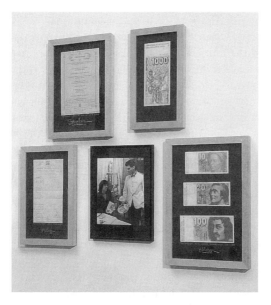

J.S.G. Boggs,
Dinner for Eight
(1987)

real dime, and four real pennies he'd received in change. (This piece was now being offered at $750.) A third piece, entitled *Printing Money/Money in the Bank*, consisted of a single aquatint print of a Boggs etching of a one-pound note (the etching itself went under the self-answering title, *How Much Does an Idea Weigh?* and this particular print was the forty-eighth out of a run of fifty), the deposit receipt Boggs had filled out in an attempt to deposit the etching *as* one pound into his account at the local Hampstead branch of the Midland Bank, and his monthly bank statement indicating that the deposit had indeed been accepted as such (his account had been credited one pound). That piece was going for $1,000.

Of course, the fact that all these pieces had now been gathered together, some as loans from private collections and other as entities available for purchase, raised some interesting questions about the initial transactions themselves. If, for instance, Boggs did in fact manage to purchase a ticket for a flight from Zurich to London on British Airways, worth 290

Swiss francs, with a drawing of three one-hundred-Swiss-franc notes (a single drawing of three *overlapping* bills), it was easy to see how the ten Swiss francs in change and the actual ticket stub had made it into this show. But how had the initial drawing managed to rejoin them, so that the entire transaction could now be offered for sale at $1,500? Over and over again, the pieces at the Neale Gallery raised such questions, and as often as not last August, Boggs was right there in the gallery avid to entertain them. He seemed to feel that the show itself was merely a continuation of the series of transactions that had begun, in each case, with his taking pen to paper—and that there was still plenty of occasion for perplex,confoundment, and revelation.

He was there, at any rate, the day I happened to wander into the gallery. He was fairly easy to recognize, because his was the face on the oversize rendition of an imaginary hundred-Swiss-franc note that dominated one wall of the show. In that poster-size drawing he'd affected a sort of seventeenth-century countenance—long hair, steady, sober gaze. In that self-portrait, he looked just like the sort of royal minister who might once have contrived the very currency of the realm, an achievement for which he'd been immortalized ever after by having his face included on its bills. And indeed, in person, there is something other-timely about Boggs. He's slight of build, with a wiry, taut body, a handsome face with sharp features, smooth complexion, high cheekbones. His somewhat narrow eyes tend to stay open just a bit longer and wider than normal (the whites occasionally visible just above the brown irises), so that he projects an intensity that is usually charming but can sometimes verge on the demonic. He likes to wear wide-collared white shirts, open at the neck, which together with his cascading long brown hair make him look like a refugee from some Renaissance Faire of the 1960s—or, for that matter, of the 1690s.

When he came up to talk to me, that first afternoon at the gallery, I asked him about the presence of those initial drawings in this show. "The thing is," he explained, "there are a lot of collectors, in Europe but also here, who want to buy my

drawings of currency—but I refuse to sell them, that's the first of my rules. I simply will not sell an unspent drawing depicting an existing denomination in its exact size. Now, as you can see"—he gestured about the room—"I've occasionally painted larger canvases of actual bills, or else pastiches with aspects of several different bills all mixed together, and those I'll sell outright. But as for exact-size, existing-denomination drawings, I will only—and this is my rule number two—I will only *spend* them, that is, go out and find someone who will accept them at face value in a transaction that must include a receipt and change in real money. My third rule is that I will not tell anyone where I've spent that drawing for the next twenty-four hours: I want the person who got it to be able to have some time, unbothered, to think about what's just transpired. After that, however—and this is my rule number four—if there is a collector who I know has expressed interest in that sort of drawing, I will contact him and offer to sell him the receipt and the change for a given price. It varies, but for the change and receipt from a one-hundred-dollar dinner transaction, for example, the collector might have to pay me about five hundred dollars. The receipt should provide enough clues for the collector to track down the owner of that one-hundred-dollar drawing, but if the collector desires further clues—the exact name of the waiter, for example, or his telephone number—I'm always prepared to provide those details as well at a further fee. After that, the collector is in a position to contact the drawing's owner and try to negotiate some sort of deal on his own so as to complete the work."

Are there people who actually go along with all this—I asked Boggs—collectors who will actually pay him five hundred dollars for, say, an ordinary ten-dollar bill, three one-dollar bills, and a dog-eared receipt? He replied that he had a waiting list of eighteen such individuals right now. "I mean," he elaborated, "not all of them will accept just anything. Some are very finicky. I've got one guy who wants a fifty-dollar transaction involving clothing—painting supplies won't do, one hundred dollars won't do. I've got another guy who told me he wanted a five-dollar transaction involving drinks at

a bar. Several months later I happened to perform such a transaction, but when I called him up to tell him, he asked me which side of the bill I'd depicted in my drawing. I told him the face side, and he said no, he was only interested in the *back*. So he'll just have to wait. I don't do commissions. I can't work to order."

Boggs went on to explain some further aspects of the mysteriously compounding value of his drawings. If a collector paid him, say, five hundred dollars for the change and the receipt to one of his transactions and then went on to pay, say, another five hundred dollars to procure the art itself, he'd then have a completed work that, at current market values in New York and London and Basel, could fetch as much as two or three thousand dollars. Boggs himself prefers to deal with the collectors directly—it is to his financial advantage to do so—but, not surprisingly, many of his collectors are professionals (lawyers and stockbrokers) who don't have the time or inclination to undertake the scavenger hunt themselves and instead choose to work through agents or dealers. Sometimes his own galleries will undertake the scavenger hunts, as it were, on spec. The various arrangements and subarrangements involving fees and cuts and so forth can get fairly complex, but this doesn't seem to bother Boggs; indeed, he usually seems to find such details as fascinating as the initial transactions.

I asked Boggs whether he might like to join me next door for a bite. He looked around—things were quiet in the gallery, not much action—and agreed. As we were walking over to the café, Boggs commented, "I hope you don't think I'm doing all this as some sort of insult to money, as if I were putting money down or something. I think money is beautiful stuff." I laughed as we entered the café. "I'm serious," he said, simultaneously pulling up a seat and pulling out his wallet, rummaging around for a moment and then extracting a one-dollar bill. "I mean, look at this thing. No one ever stops to *look* at the bills in their pocket, just stops and admires the detailing, the conception, the technique. Part of my work is intended to get people to look at such things. Take this one here. This

is an absolutely splendid intaglio print. It's actually the result of three separate printing processes—two on the face side, another on the back—all done on excellent, high-quality paper. Over the years, because of the danger of counterfeiting, they've had to make these bills more and more intricate, both in terms of imagery and technique. But as far as I'm concerned, money is easily more beautiful and developed and aesthetically satisfying than the print works of all but a few modern artists. And a dollar bill *is* a print: it's a unique, numbered edition. Few artists today understand the special nature of printmaking. They just try to translate their painting ideas into prints, and the results are usually mediocre. I mean, look at a Howard Hodgkin print. As a painter, he's the artist I admire perhaps more than any other in England. But in his prints, the color temperatures get lost. I'd rather have a dollar bill than just about any other modern print, even if I knew I could sell the print the very next day for several thousand dollars!

"And that's just talking about technique," Boggs continued. "Now look at the content, the iconography, the history. That crazy rococo profusion of leaves and scrollwork, symbolizing prosperity. The eagle with his thirteen arrows in one claw, one for each of the first thirteen states, and the olive branch in the other—and on the olive branch, the olives! And then the other half of the Great Seal, with that strange Masonic pyramid—an unfinished pyramid, one still in the process of being built. George Washington, on the facing side of the bill, was a Mason; the man who designed the seal was a Mason. There's so incredibly much of American cultural history wrapped up in this little chit of paper. And it's the same with other currencies. In England, I particularly love the fifty-pound note. On one side there's a phoenix, rising gloriously from the ashes. On the other, there's St. Paul's Cathedral. And anybody familiar with the history of England would realize that the imagery on that bill harkens back to the Great Fire of 1666—which destroyed the original cathedral along with much of the rest of London—and celebrates the long and glorious labor of reconstruction that followed."

Boggs paused for a moment, continuing to gaze at his dol-

lar. "'In God we trust,'" he said. "Did you know that that phrase wasn't always part of our currency? They only started putting it on during the twenties and thirties as they withdrew the dollar's gold backing. It used to be you could redeem a ten-dollar bill for ten dollars in gold. In fact, originally dollars *were* coins, they were a particular kind of coin; the word derives from the word *taler*, which was short for *Joachimstaler*, which is to say the coins originally minted at the Joachimstal mine in Bohemia. Some of the early American paper bills included engravings on the back depicting the metal coins for which the paper bills could at any moment be redeemed. On the back of the five-dollar silver certificate, put out in 1886, there was a picture of five silver dollars. If you wanted to know what a five-dollar bill represented in those days, all you had to do was look at the picture on the back. But anyway, when they started withdrawing the dollar's metal backing— when you couldn't redeem your dollars for gold and in fact were no longer allowed even to possess gold on your own except as jewelry—that's when they started putting that phrase on the currency. When you could no longer trust in gold, they invited you to trust in God. It was like a Freudian slip."

The waiter came over and Boggs ordered some coffee and a sandwich. "It's all an act of faith," he continued. "Nobody knows what a dollar is, what the word means, what holds the thing up, what it stands in for. And that's also what my work is about. Look at these things, I try to say. They're beautiful. But what the hell *are* they? What do they do? How do they do it? Take this one here." He pulled a crisp five-dollar bill out of his wallet. "'Five dollars.' But what's a dollar? By now, it's just an idea. For that matter, what's 'five'? It doesn't exist either. I mean, you can have the numeral"—Boggs traced a 5 on the tabletop with his finger—"the written word *f-i-v-e*, the sound *five* as I say it. But five itself doesn't exist, except as a concept. So you've got these two ideas joined together and they represent something else: they stand in for something you might eventually buy, for instance, but nothing in particular. And then I make a drawing of a five-dollar bill, and that's *another* order of

representation: it's something that represents something that represents something but not anything in particular."

The waiter delivered his order, and Boggs took a few bites. "It's incredibly difficult to make something that's worth a dollar," he said. "As much as a dollar, only a dollar, exactly a dollar. The only thing that has that exact value *is* a dollar. With anything else, its value is constantly changing—including, of course, my drawing of a dollar."

Boggs gazed down at the two bills on the table, then picked them up and slid them back into his wallet. I noticed that they were all the money he had. "Before I got into these money pieces, I was doing a series of things about numbers. I like money, but I *really* like numbers. They're incredibly beautiful: perfection in terms of manipulated geometry. Over the years they've been honed and honed, as to form, so that today, for example, the muscles you use in your hand and arm in order to make a 5 combine into a gesture that just *feels* good. And numbers comprise a universal language. You can go virtually anywhere in the world, you might not be able to understand a word of the local dialect, but if you've got the right numbers on a sheet of paper, you've got the potential for a relationship with someone. Chinese, African, American bills all bear the same numerals. This just used to amaze me.

"I'm already a little bit crazy: lock me away in a studio with a notion like that and I can just about lose it. I was doing all kinds of things with numbers—passport numbers, Social Security numbers, credit card numbers, license numbers, phone numbers . . . images of people lost in whirlpools of numbers, or buoyed on seas of numbers, portraits of people in which the faces were entirely made of numbers. Eventually I found myself just doing portraits *of* numbers, wild expressionist renditions of twisted three-dimensional numerals that seemed to take on a

J. S. G. Boggs, *Shooting 5* (1984)

sort of physical presence. I spent so much time with them that they started taking on *personalities* of their own. Some were quiet and sad, others stoical. I knew a 5 that was definitely spoiled and rowdy, there's no other way I could describe him. I almost started relating to them as if they were alive." Boggs sipped his coffee. "It got strange . . . real strange."

— —

He was silent for a few moments, staring out vacantly. I asked him about his background. For one thing, what did the J.S.G. stand for? "James Stephen George," he replied noncommittally. "My parents and my childhood friends call me Stephen, but now I prefer to go by Boggs. Actually Boggs isn't the name I was born with. My biological father and my mother divorced when I was very young; Boggs is my stepfather's name, the man I consider my father. My mother married him when I was about five, and he subsequently adopted me. I was born in New Jersey in 1955; we moved around a lot when I was a kid, but we eventually settled in Florida. My father used to be a citrus grower, now he's an investor. He's a lot more conservative than I am, he's more into the security money can provide. My mother thinks this whole money series stems from a wish on my part to please him, to make contact with him. I don't know that that's true, but it does seem like these are the first of my works he's gotten into at all. I did a large pastiche painting of an English pound note a while back, and up in the corner where an actual pound note says 'Bank of England: I promise to pay the bearer on demand the sum of 1 pound,' mine says, 'I promise to promise to promise to promise.' When my dad saw that, he told my mother, 'That's a brilliant work of art. People don't realize how true that is.' In fact, he'd been the one who'd explained it to me in the first place."

I asked Boggs about his educational background. "I never graduated from high school," he said. "I was kicked out of the eleventh grade." Over what? "Oh, it was nothing—just bullshit. I was accused of starting a riot in the auditorium, but it was somebody else who threw the book at the principal. Still,

it was no great loss. I was bored senseless at school. I got a job working in a printing company, and in my spare time I wrote a play, and then I started working the night shift so I could earn the extra money I needed to rent a theater and mount a production of my play. Ever since then I've been working sixty hours a week at least. For a while I managed a rock group. Then I went up to Ohio where a friend of mine had moved. I got a position in a management training program with Holiday Inn, and they sent me to Miami University there in Oxford for a semester or two. I was trying desperately not to be an artist. I was in a business program, majoring in accountancy, I was even tutoring accounting. But it wasn't working. I've tried several times to quit—Lord knows, I'd have an easier life if I could—but every time I stop making art for any length of time I go crazy, literally. I've been on intimate terms with suicidal depression."

He sighed. "Anyway, I came back to Florida, spent a year at Hillsborough Community College in Tampa majoring in art, and then, during my summer vacation in 1978, I went to London for what I thought would be a month—only, for the first time in my life I really felt *at home*. I called my parents and told them I wouldn't be coming back. I stayed on in London, though as a foreigner I couldn't afford art school and that became frustrating. That Christmas I came back here to New York, and a lawyer friend of mine said he was going to take me over to Columbia and see if he couldn't get me admitted to the arts program there. The dean of admissions was dubious (he threw out my application—after all, I hadn't even graduated from high school), but one of his assistants interceded on my behalf, and they decided to admit me on a special basis as of January 1979. And that's how I come to have a degree from Columbia."

He paused for a moment and then smiled, both crafty-sly and utterly transparent (a combination I often noticed in the days ahead). "I mean," he said, "I have a piece of paper—a blank one. They gave it to me a year later on condition I'd leave. I kept signing up for classes for which I didn't have the prerequisites—studio art, economics, Russian—and they said,

okay, we'll let you take these advanced courses but you have to take these other required courses, too. I said, 'Look, I'm working full-time, I'm painting full-time, I'm going to school full-time, and you want me to take all these classes I have no interest in?' They said, 'Take it or leave it.' So, I left it. I visited my sponsor at the admissions office, and he said, 'You're right, there's nothing more we can offer you, you don't need it, you're already a master.' He laughed, opened his drawer, and handed me a blank diploma. I was on the next flight back to London. I didn't even clean out my locker."

Boggs described how he got various odd jobs in London, and how he occasionally tried to kick his art habit, only invariably to fail. In August 1983 he started painting full-time once again and he's been doing so—frequently in perilous financial circumstances—even since. He'd paint portraits, or, as he puts it, 'exchange one sort of a portrait on paper for a handful of other sorts of portraits on paper.' For a while, he was painting objects—the objects themselves. He did a painting of a suitcase—or rather, onto a suitcase—that he called *Home*. He did a series of more conceptual works, including one that consisted of a blank canvas scrawled over with hundreds of signatures—his own signatures—one of which, he explained, wasn't a signature but rather the autograph with which he signed the piece. And, increasingly, he got into numbers.

I asked him about the more immediate origin of his current money series. He explained that while based in London, he'd often traveled to countries where he didn't speak a word of the native language, and so he'd sometimes pull out his sketchpad and draw a picture to convey the things he wanted, and that sometimes he'd trade the drawings for the objects. But actually, he said, the money pieces had their real origin in the United States.

"I was in Chicago one day in May 1984," Boggs recalled. "I'd gone there for the Art Expo, and I was sitting there in this diner, having a doughnut and coffee and doodling on this napkin, as I'm given to doing. I started out by sketching a numeral, a *1*, and gradually began embellishing it. The waitress

kept refilling my cup and I kept right on drawing and the thing grew into a very abstracted one-dollar bill. The waitress came up to ask me if I wanted *another* refill—I was already caffeined right out of my face—and she noticed the napkin, and she said, 'Wow, that's great. What are you going to do with it?' I said I didn't know. She said, 'Can I buy it?' Here was this greasy napkin, covered with coffee stains and an hour's worth of hand perspiration—and here was this woman wanting to buy it. So, my immediate reaction was, 'No, you can't buy it.' I could see the disappointment in her face. She offered me twenty dollars. No, I told her, it's not for sale. Then she offered fifty. I just shook my head and asked her how much I owed her. She said ninety cents. I said, 'Tell you what: I'll pay you for my doughnut and coffee with this drawing.' And she was over the moon. This set me to thinking: what was it that she valued so much? Was it the way the drawing mimicked a regular dollar bill? or the fact that she'd sat and watched me do all the work? or that it somehow succeeded as a drawing in communicating something? I got up to leave, and she called out, 'Wait a minute. You're forgetting your change.' And she gave me a dime. We smiled, and I walked out.

"For a long time, I carried that dime around in my pocket. I'd rub it like Aladdin's lamp, and the genie of memory would appear. I still have it. I keep it in my London studio along with my other valuables."

Our waiter brought over a refill, as if on cue, and Boggs continued. "Several months later, back in London, I was telling an artist friend about all this, and he said, 'Ah well, that's America for you. That could never happen in England.' I said that I bet it could. So I began a drawing of a five-pound note. I spent four days doing it, and then we set out to try and spend it. Well, you have to be persistent. We started out at 11:00 A.M., we went to place after place, all different kinds, restaurants, magazine stands, clothing stores—wealthy neighborhoods, poor neighborhoods, trendy ones. And everywhere the answer was no. We eventually wound up, exhausted and depleted, at this Covent Garden pub. We ordered drinks and

I pulled out the drawing and the guy behind the counter said, 'Yeah, sure, I'll take it.' Just like that. And he gave me change. My friend Warren was amazed.

"Anyway, that was in November 1984, and I figured I'd proved my point. In January 1985, I started work on a major painting, four by eight, which gradually turned into a sort of pound note. It said *one pound* in one corner, *five pounds* in another, *twenty pounds* in a third, and in the middle it said *six pounds*. This was the painting where I wrote 'I promise to promise to promise. . . .' I called it *Pined Newt*, after the way snobby upper-class Brits pronounced the words, you know, almost as if holding them from a distance. Anyway, I worked on that painting for almost a year, maybe twenty hours a week. And toward the end of working on it, I started to become aware, what with my mounting debts, how very much it was *costing* me to make art.

"In May 1986, at the International Contemporary Art Fair in London, I exhibited *Pined Newt* at the booth of an unconventional local gallery called Fort Apache. At that point I was $20,000 in debt and I was just about to declare bankruptcy, but the *Pined Newt* sold. I got fifteen hundred pounds, thereby temporarily saving my ass. But then I looked and saw— what?—easily a thousand hours of work, years of study, all my expenses for supplies, all my natural talent—and although I was grateful for the fifteen hundred pounds, I became pretty depressed. Around that point I decided to try to start subsidizing myself through my drawings of money."

Things didn't go very well at first. The enterprise was hardly more profitable on a per hour basis than the *Pined Newt* had been. The drawings took hours, sometimes days, to complete and further hours to spend: often merchants who had things Boggs wanted to buy wouldn't accept his bills, whereas those who didn't have a thing he needed seemed to take a fancy to the drawings. The British in general weren't all that open to such playful artistic license. At one level, Boggs values this sort of indifference. As he'd told an interviewer for a marginal London art journal around this time, "You don't paint to sell in London. And you can do anything you want.

You are free. Chances are no one is going to buy it anyway, and the galleries are probably not going to want to talk to you no matter what you paint. So you can paint whatever your imagination, talents, and abilities can stretch to." Which was all well and good. But it didn't pay the rent. In fact, one day it got to the point where Boggs could only pay his rent with a money drawing; luckily his landlord was willing to entertain such curious recompense at least this once. Still, Boggs's prospects did not appear particularly sanguine.

It happened, however, that a Swiss dealer had seen *Pined Newt* at the London art fair and had wanted to buy it, even though it had already been sold. Hansruedi Demenga, who runs two galleries in Basel, did manage to meet Boggs, however, and invited him to Switzerland the following month for the annual Basel Art Fair.

"My first night in Basel," Boggs now recalled for me, "Rudy took a group of eight of us to a cheap artists' restaurant, and while we were there, I took out a Bic pen and started drawing a one-hundred-Swiss-franc note on a napkin. A hundred Swiss francs is about the equivalent of fifty-five dollars. Anyway, when the waitress came with the bill, I offered her my drawing and she took it without so much as a question. I proceeded to draw two more notes and took them along to the evening's next stop, a disco named Totentanz, the Dance of Death, where I immediately succeeded in spending them, too. My first night in Switzerland, and I'd already spent three drawings!

A Boggs Swiss thousand-franc bill

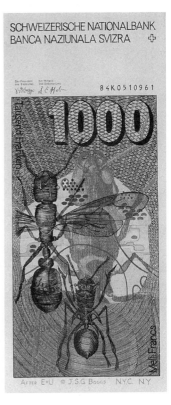

SCHWEIZERISCHE NATIONALBANK
BANCA NAZIUNALA SVIZRA ✚

84K0510961

1000

"The following day I just kept at it. Every time I offered one of my drawings, it seemed, I'd obtain what I wanted, and people were giving me real money in change—even though I couldn't speak a word of the language. I was spending money like a drunken sailor, buying rounds of drinks, taking taxis, buying clothes. The first few nights I stayed at Rudy's home as his guest, but after a while I arranged to move into a five-star hotel, and they agreed to accept drawings in lieu of payment for my entire account. It was incredible."

I asked Boggs why he thought the Swiss proved so open to his offers. "The Swiss get a bum rap," he suggested. "People think of them as stodgy and conservative and uncreative. I found the average people I met to be quite open, with a very high level of general education and interest in art. And beyond that, they tend to understand value, and to understand risk. They'll look at a drawing and understand that it's an object of worth, and of such-and-such a worth. They're a nation of bankers, and they're used to assessing value on an everyday basis. They look at your offer and then they move on it, right there, decisively. They seem comfortable with their own evaluations. They don't need somebody to hold their hand."

Boggs resumed his saga: "Back at the artists' café, Rudy had offered me one hundred Swiss francs in real money for that first one-hundred-Swiss-franc drawing. But I explained to him how a few weeks earlier, a dealer in London had made a similar offer: he'd said he'd be willing to buy as many drawings as I could generate at face value, and we'd gotten into a fight, me insisting that as art objects they were certainly worth more than face value, and him refusing to pay more. Things got a little heated, and finally I swore, 'On my word, I will never sell these drawings. If you want one, you'll have to go track it down and then see how much you'll have to pay for it.' So I told Rudy I couldn't sell it to him either. I'd already fallen into my first rule. After a couple of days, though, Rudy had told several friends about me, and he had several collectors eager to buy any of my drawings. I told him he'd have to track them down, I couldn't remember where I'd spent them. I reached into my pocket and extracted a handful of receipts. (I

never throw anything out; you should see my London studio.) Meanwhile, Rudy suggested that I henceforth write on the back of my drawings 'Galerie Demenga will redeem at face value'—supposedly this was to protect me legally. And I did do that for a few days. But after a while I stopped, because it began to feel like a con."

I asked Boggs whether anyone took the Galerie Demenga up on its offer. "The funny thing was," Boggs replied, "people would go to the gallery to show their drawings and ask if it was really true that the gallery would redeem them at face value. Rudy or his assistants would say, 'Absolutely,' but then the people would say that they weren't interested in selling them, they'd just been curious. Finally, in exasperation, Rudy went on the local radio station and announced, "There's an artist here in town named Boggs who's spending drawings of Swiss franc notes. He won't sell any of them to me. I hereby announce that if it's a real Boggs, the Galerie Demenga will pay *ten times* face value.' After that, I *really* got popular. Cabbies were almost colliding in their haste to pick me up whenever I stuck my hand out."

I asked what Demenga had meant by "if it's a real Boggs." "That was the other crazy thing," Boggs explained. "Because people started coming into Demenga's gallery with counterfeit drawings and claiming they were by me. I quickly developed a series of consistent idiosyncrasies in my own renditions—I now have seven of them, such as the fact that I always mismatch the two serial numbers on the face of any of my bills (only one of them is correct, I usually leave a digit out of the other)—so that Demenga would be able to identify the real Boggs bills. One time I happened to be in the gallery and a guy came in with a drawing of a one-hundred-Swiss-franc note that he wanted to redeem and they told him it was obviously a fake, but that it was a *good* fake, so that though they wouldn't honor it at ten times face value, they would offer him face value itself. 'Are you kidding?' the guy exclaimed. 'Do you know how long it took me to make this thing?' Whereupon he stomped out in a rage. Which, of course, was my point precisely."

Boggs went on to explain that it was in Switzerland that he began to discern the wider possibilities of his medium. Faced with so many successful transactions, and such interesting ones, he began to sense how the transactions themselves, beyond the simple drawings, were the true aesthetic objects. "I'd been saving the receipts and after a while I started saving the change, too, and presently I was even saving the actual bills I'd used as models for my drawings. And I was trying to figure out what to do with all this stuff. One evening, after I'd spent my biggest denomination yet—a five-hundred-Swiss-franc note at the Hotel Euler—I called Dr. Robert Kahn in London, who's become a sort of patron of mine. I quickly explained the situation, and I concluded by saying, 'So I've got this receipt and one-hundred-and-ninety Swiss francs in change and what I want you to do is buy them from me for . . . oh, I'll give them to you for three hundred Swiss francs.' He hesitated for a moment, but then he took them. And then he went back to bed. Because I'd called him at about two in the morning."

After that, all the principal ingredients of Boggs's new art form were in place. For the next several months he would just go on going on. "I used to get so tired," Boggs concluded, "of people asking me how much money I'd made as an artist over the past year. Now, however, on any given day, I can tell them exactly."

It was getting late, and I asked Boggs if he had any drawings he might like to try and spend here at the café in payment for our meal. But he said, no, he was fresh out of art. "As I say," he explained, "it takes me a long time to draw them. But I'm planning to draw a few more bills in the next few evenings and then I'm going to go out and try to spend them." I asked if I could join him on his spree, and he said sure. We agreed to meet back at the gallery three days hence.

In the meantime, I picked up the tab.

— —

Boggs had almost accidentally stumbled upon the terrain but then decided quite deliberately to pitch his tent there along

the fault line where art and money abut and overlap—and his current work has definite ramifications in both directions. The questions it raises start out as small perturbations: How is this drawing different from its model (this bill)? Would you accept it in lieu of this bill? If so, why? If not, why not? But they quickly expand (as you think about them, as you savor them) into true temblors: What is art? What is money? What is the one worth, and what the other? What is *worth* worth? How does value itself arise, and live, and gutter out?

During the next few days I spent a lot of time at the library. I began with Georg Simmel, the great German-Jewish philosopher and sociologist whose *The Philosophy of Money* was published in 1900. In its final pages, Simmel concludes that "there is no more striking symbol of the completely dynamic character of the world than money. The meaning of money lies in the fact that it will be given away. When money stands still, it is no longer money according to its specific value and significance. The effect that it occasionally exerts in a state of repose arises out of an anticipation of its further motion. Money is nothing but the vehicle for a movement in which everything else that is not in motion is completely extinguished." But if in one of its aspects Simmel saw pure motion in money, in another he located an absolute stillness. "As a tangible item, money is the most ephemeral thing in the external-practical world; yet its content is the most stable since it stands at the point of indifference and balance between all other phenomena in the world. . . ."

It occurred to me that Boggs's work operates in the space between those two absolute characterizations. He momentarily slows the mindless frenzy of exchange, forcing us to mind it; and in so doing, he briefly forces the age-old monolithic stasis to budge and shudder. It's a sort of magic. But then, all art is magic (we *knew* that), and so is all money.

"Although it is an ancient fact of life, or rather an ancient technique," Fernand Braudel writes in *The Structures of Everyday Life* (the first volume of his magisterial history of the progress of civilization and capitalism from the fifteenth through the eighteenth centuries), "money has never ceased

to surprise humanity. It seems mysterious and disturbing . . . [and] complicated in itself." While chronicling the resurgence of money and exchange in late medieval and then Renaissance Europe, Braudel quotes one contemporary characterization of this new presence, money, as "a difficult cabala to understand."

That primordial sense of the mystery initially surrounding money in turn dovetails nicely with a famous passage from Norman O. Brown's visionary *Life Against Death*, the 1959 book in which Brown attempted to fashion a reconciliation of Marx and Freud. Brown had earlier pointed out that "it is essential to the nature of money for the objects into which wealth or value is condensed to be practically useless. . . . This theorem is equally true for modern money (gold) and for archaic money (dog's teeth)." Brown goes on to suggest that money therefore consists in the transubstantiation of the worthless into the priceless (of the "filthy" into "lucre"): "The sublimation of base matter into gold is the folly of alchemy and the folly of alchemy's pseudosecular heir, modern capitalism. The profoundest things in *Capital* are Marx's shadowy poetic presentiments of the alchemical mystery of money and of the 'mystical,' 'fetishistic' character of commodities. . . . Commodities are 'thrown into the alchemical retort of circulation' to 'come out again in the shape of money.' 'Circulation sweats money from every pore.'" This, for Brown, is where Freud comes in, because "Freud's critique of sublimation foreshadows the end of this flight of fancy, the end of the alchemical delusion, the discovery of what things really are worth, and the return of the priceless to the worthless. In a letter to Fliess, Freud writes, 'I can hardly tell you how many things I (a new Midas) turn into—excrement.'"[1]

One can hesitate before the grandeur of Brown's prophecies regarding any imminent recovery of true worth (I mean, maybe, but we're certainly not there yet) and still admire the suggestiveness with which its formulation frames the issue:

1. "Sometimes I feel like a gigantic digestive tract, taking money in at one end and pushing it out at the other. But in fact a considerable amount of thought connected the two ends." (Financier and philanthropist George Soros in his latest book, *The Crisis of Global Capitalism*.)

money as an alchemical delusion. How did money arise—and more specifically in the current context, where did *paper* money come from?

Anthropologists have all sorts of theories about the origins of money itself. One of the more intriguing was posited, about a decade ago, in an art exhibition catalogue of all places—the catalogue to the Düsseldorf Städtische Kunsthalle's extraordinary "Museum des Geldes" (Museum of Money) show in 1978. That show, jointly curated by the Kunsthalle's director, Jürgen Harten, and his anthropologist friend Horst Kurnitzky, surveyed the recent history of artists' works on the theme of money, but it began with and was grounded in a theoretical framework established by Kurnitzky. Kurnitzky suggested that money had its origins in ancient rituals of sacrifice and expiation. These ceremonies originally involved human sacrifice, but as time passed, priests became empowered to substitute, through various arcane and sacred rituals, other beings—for example, pigs—for the human victims. Kurnitzky suggests that this exchange of one entity for another formed a sort of ur-model for all later substitutions, exchanges, and trades—served, that is, as a sort of precursor to the very notion of money. One doesn't have to buy that entire thesis or any of its corollaries (Kurnitzky and Harten's

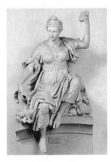

Juno, the One Who Warns

suggestion, for example, that the ancient pig-sacrifice rituals live on into the present day in the form of piggy banks, or their suggestion that the surrealist movement tapped into a deep intuitive understanding of the links among dreams, sacrifices, and money) to acknowledge that in its earliest incarnations, the creation and control of money was almost invariably a priestly function. The earliest vaults were temples. The very word "money" harkens back to the Latin epithet for Jupiter's wife—Juno Moneta—in whose temple the mint was located.[2]

2. Which only begs the question, why was Juno in this particular incarnation known as Juno *Moneta*? Well, it turns out that around the year 390 B.C., when besieging

The earliest, most primitive economies consisted of self-sufficiency in most things and barter for the rest. You had wool, I had corn—we traded. This sort of economy was predicated, however, on what the economist W. S. Jevon has called "the double coincidence of wants." Otherwise things quickly became complicated: you had wool, which I wanted; I had corn, which you didn't; but he had a blade and she had a basket, and you wanted his blade, she wanted my corn, he was willing to trade his knife for her basket . . . and so forth. As these exchanges became ever more convoluted, certain commodities kept recurring and gradually became mediums of exchange, standards by which the other potential items of trade could be measured. These "commodity moneys" had to fulfill certain requirements—they needed to be convenient to transport and store and subdivide, for example, and they needed to be somewhat durable—but beyond that, they could consist and have consisted in any of a remarkably varied and arbitrary range of items. At one time, cows were the medium of exchange in Italy, and the Latin word for cattle, *pecus*, was the root of another Latin word for money, *pecunia*, which, of course, survives in our own "pecuniary." On the Fiji Islands, whale teeth were used, tea bricks were used in many inner areas of Asia, camels in Arabia; American Indians traded wampum (strings of shells), early Canadian colonists used playing cards, and colonial Virginians made tobacco leaves their legal tender in 1642. I've read of woodpecker scalps being used as money, though I don't know where and can't imagine how. In Romania today, the underground economy for some reason runs on unopened packs of Kent cigarettes (ten pounds of lean beef going for one carton). And then, of course, there were the precious metals—especially silver, to a somewhat lesser extent gold, and for more modest transac-

Gauls secretly attempted late one night to scale the walls of the citadel of the Roman Capitol, it was the sacred animals in this particular temple, Juno's geese, whose frantic squawkings and cawings alerted (Latin *monere*, to warn) the defenders as to their peril. Hence, it's no exaggeration to suggest that embedded in the very origins of the word "money" is the eternal exhortation to "Watch out!"

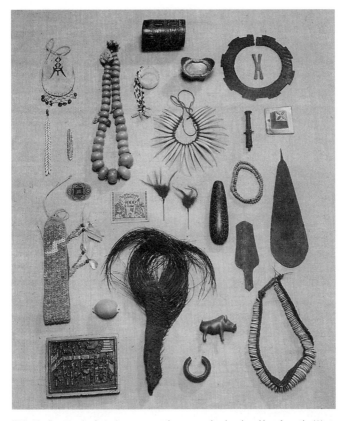

"Primitive" currencies featuring, among others, an amber bead necklace from the West Coast of Africa (where one large bead was worth four cows); a shaved whale-tooth necklace from Fiji; a pair of honey-bird feather sticks from the Solomon Islands; and an elephant tail from nineteenth-century Congo (worth two to three slaves).

tions, bronze and, later, copper. Coins minted from these materials were common throughout the Mediterranean region during antiquity, but tended to subside (as did trade) during the early Middle Ages, only to resurface in the later Middle Ages, the period at which Braudel's account begins.

Money must have seemed "complicated in itself," Braudel writes, for not even in France was the monetary economy

fully developed, even as late as the eighteenth century: it made its way into certain sectors and certain regions and left others utterly undisturbed. Wherever it did penetrate, however, it provoked profound transformations. "What did it actually bring?" asks Braudel. "Sharp variations in the prices of essential foodstuffs; incomprehensible relationships in which man no longer recognized either himself, his customs, or his ancient values. His work became a commodity, himself a 'thing.'" By way of illustration, Braudel reports the testimony of sixteenth-century Breton peasants, who expressed confusion and astonishment at how much less abundance they now had in their homes because "chickens and goslings are hardly allowed to come to perfection before they are taken to sell for money to be given either to the lawyer or the doctor (people formerly almost unknown), to the one in return for dealing harshly with his neighbor, disinheriting him, having him put in prison; to the other for curing him of a fever, ordering him to be bled, . . . or for a clyster; all of which our late Tiphaine La Boye of fond memory [a bone setter] cured, without so much mumbling, fumblings and antidotes, and almost for a Paternoster."

"History," Braudel concludes, "shows us an endless procession of these condemned men—men destined not to escape their fate. Naïve and astonishingly patient, they suffered the blows of life without really knowing where they were coming from." Braudel himself, however, does not long tarry in this elegiac melancholy. Explaining that money was a symptom rather than the cause of the burgeoning monetary economy ("Its flexibility and complexity are functions of the flexibility and complexity of the economy it brings into being"), Braudel soon moves on to the sort of dazzling inventory of particular details that he so clearly relishes. Some that I particularly relished involved early European impressions of travel in China where, according to contemporary accounts, everyone, "however wretched he may be," carried around large scissors and precision scales (so as to be able to cut from loaves of silver and weigh the slices), and little wax-filled bells with which to scoop up any random splinters (when they'd ac-

cumulated enough splinters, all they had to do was melt the wax).

The precious-metal based trade economies, however, had many internal problems. For one thing, while a chest of coins was considerably more convenient to lug around than a herd of cattle or a brace of woodpecker scalps, it still wasn't *all that* convenient (or safe) to cart around. Furthermore, over the years, there tended to be a flight of metal out of Europe toward Asia, which was fine at one level—Europe got silks and spices and so forth in return—but, when compounded with the problem of hoarding, it meant that at times, in certain places, the currency of exchange would dry up almost completely, at which point trade would become, in the words of one contemporary witness, "an occupation of much perplexity."

I took a break from such reading, one afternoon, to lunch with Robert Krulwich, the economics correspondent for National Public Radio and CBS television, who, I happened to know, was also a Boggs enthusiast. (Indeed, he was planning to air a short piece on Boggs himself.) Krulwich's reports are prized as much for their crystalline clarity as for their droll perspective, and when I asked him to help me understand the transition from metal to paper money, he didn't disappoint me. "Well," he said, "I suppose you know all about the camels and the cows and the woodpecker scalps and all that, so I won't bore you with them. But anyway, eventually people are using gold coins and baubles in their transactions, and they occasionally have to break up these pieces or the jewelry or whatever as they go about their business. Every so often they then take the remaining pieces and whatever new scraps they've picked up along the way to their neighborhood goldsmith, for him to refashion all the scraps into something more presentable, or maybe just into a bar. The goldsmith weighs it all, and then he hands his customer—let's say the customer's you—a marker, an IOU, a little chit of paper saying how many grams you've left with me and can expect to get back. I'll be the goldsmith. Now, you can take that marker and exchange it for goods, say, with the wine merchant, who would then be entitled to redeem it with me for the gold or else just

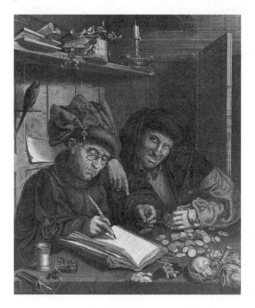

Quentin Matsys (1466–1530), *The Misers*. Early banking as portrayed by the Flemish master.

to keep it circulating (which might be more convenient for him, what does he need with the gold?). Okay, so I'm the goldsmith and one day I'm sitting there and I say, hmmm, I've got all this gold and I know all these markers are circulating, but you know what? They're not going to all be redeemed at once. I can issue a few extra markers and get some goodies for myself (I hear the wine merchant has some good stuff this week) and nobody's going to be the wiser. It's risky but it's not that risky. Well, that's the line of reasoning that makes me the grandfather of the first bankers.

"I'm oversimplifying, but that's how paper money really gets going. Bankers a few generations down the line are issuing IOU's on their own, backed only by their say-so that they have enough on reserve to cover them—and in some places in the world you still see traces of this. You can go to a powerful place like Hong Kong and you think something like the queen or the government is backing up the money—but when you turn over the little scrap of paper all you see is a picture of the bank—the building itself!

"Now," he continued, "one of the things that's interesting is that paper money circulates but that doesn't drive out the gold, just as the gold didn't completely drive out the barter. Everything exists side by side. Then in the 1830s you begin to get checking, which is a method whereby I sign a piece of paper instructing my bank to give you some of their other kind of paper. As usual, this innovation first gets accepted by the elites, but it gradually spreads throughout the society, and meanwhile, paper bills and gold and barter continue right on alongside.[3] Little by little the various backings of the coins get withdrawn—you can no longer redeem your check for a paper bill that you can redeem for gold and silver: Now, all you can exchange your old bill for is a new bill. But by the 1960s, people (again starting with the elites) are using fewer paper bills and checks anyway: they've started using credit cards, which are just sequences of numbers splayed onto carbon paper. And now, in the eighties, we're even getting rid of carbons, it's all becoming electronic—my number telling my bank's number to transfer such-and-such an amount to this supplier's bank's number. It's becoming more and more invisible. Nowadays, half a trillion dollars exchanges hands every day—although no hands are involved, and in a sense no dollars either, and not even numbers really. It's just binary sequences of pulses racing between computers.

3. There are, of course, still places in the world into which the institution of checking has not yet penetrated. Until just recently, the entire Soviet Union constituted one such zone. However, according to a recent report over National Public Radio, late in the day, the former Soviet Union began to introduce personal checking as part of its *perestroika* in financial services. That introduction, however, was slow—shopkeepers had to be trained to accept checks—and irksomely cumbersome: if a bank customer happened to lose his checkbook, his entire account was frozen and he couldn't get at any of his own money until the checks themselves became invalid, which could be as long as two years. One Soviet official was quoted as saying that this was still a lot better than losing the money itself, in which case the customer would *never* get any of it back.

An obverse version of this same sense of perplex, regarding bank checking, was succinctly captured in the bumper sticker I recently witnessed gracing the flank of a car in Manhattan whose owner commonsensically demanded to know, "HOW CAN I BE OVERDRAWN WHEN I STILL HAVE CHECKS?"

"In the midst of all that," Krulwich concluded, "this fellow Boggs has found a way to illustrate, to act out, the essential nature of exchanges and money. He forces us to see, among other things, how it's all a fiction, there's nothing backing it, it's all an act of faith. In a way, though, he's in a bit of a retro position. He's still back with the goldsmith and his grandson, the banker—drawing money. The challenge for the next Boggs—or else, maybe the *next* challenge for this Boggs—will be to find some way of commenting on all the invisible traffic."

— —

Back at the library I continued reading Braudel and others on the origins and development of paper money: "This type of money that was not money at all," Braudel writes, "and this juggling of money and bookkeeping to a point where the two became confused, seemed not only complicated but diabolical. . . . The Italian merchant who settled in Lyons in about 1555 with a table and an inkstand and made a fortune represented an absolute scandal." (This Italian, in a sense, sounded like one of *Boggs's* grandfathers.) In 1682 William Petty published a question-and-answer manual entitled *Quantulum-cumque Concerning Money* (roughly translated "The Least That Can Be Said Concerning Money"), and his answer to question 26, "What remedy is there if we have too little money?" was simple: "We must erect a Bank." By the early seventeen hundreds, the Scottish banker John Law exulted over "the business potentialities of the discovery that money—and hence capital in the monetary sense of the term—can be manufactured or created." As Braudel writes, "This was . . . a sensational discovery (a lot better than the alchemists!)." And again, alchemy seems the appropriate analog: not long before, serious scholars had been laboring over vats and retorts, trying to distill gold out of manure. Those who got distracted along the way became the early chemists; those who kept their attention on the main goal became the early bankers. For in fact paper money *did* seem to create wealth out of nothing.

(In this context, it occurred to me—as it no doubt has to Boggs as well—that the odd thing about art is that it recapitulates the confusion about paper money: why, and how, it is worth *anything*?)

Miles DeCoster, in a curious but extremely lively monograph entitled "Iconomics: Money," notes that the solidity of that newly created wealth could be illusory: "Experience showed that in expansive times a reserve of coins equal to less than 10 percent of the value of the notes issued would suffice. Experience also showed that in times of contraction the value of such notes could disappear as quickly as it appeared. So, too, could a bank." The fact is that, though unlikely, a day could indeed come when everyone at the same time would try to redeem his markers with the goldsmith or his grandson— and the result would be a magic collapse: wealth turned right back into manure. John Law himself found this out when the national bank he founded in Paris, soon after the death of Louis XIV, went from phenomenal growth to cataclysmic rupture in just a few years, with the bursting of the Mississippi Bubble in 1720. Earlier, much of the "Tulipmania" that possessed Holland in 1636–37 had been paper-driven, as Simon Schama has masterfully shown in his recent *The Embarrassment of Riches*. People

weren't so much trading the tulips themselves as paper futures on next season's tulips. Speculation ran rampant, causing great disquiet among the more sober-minded burghers who saw the process, according to Schama, as "a kind of economic alchemy whereby fools imagined they might turn mere onions (the bulbs) into gold." (In

Crispin van de Pas Younger, *Floraes Mallewagen*, (1637, detail). Tulipmania grips the Netherlands.

one passage, which has uncanny resonances with the situation of the art market today, Schama notes that tulips had been around in Holland for several decades before the mania. They'd originally been imported from Turkey, and their cultivation was initially prized by a relatively small band of gentleman horticulturists. Things began to change in the mid 1630s, however, and "it was this transformation [of the tulip] from a connoisseur's specimen to a generally accessible commodity that made the mania possible.") At any rate, of course, there, too, the bubble burst, and tremendous (paper—and real) fortunes were lost almost overnight.

Paper money was particularly favored in England's American colonies, where a perennial shortage of coins throughout this period tended to famish trade. According to Miles De-Coster, some issues were private (he cites one paper certificate with the inscription, "I promise to pay the bearer three pence on demand, Azariah Hunt, Trenton"), but others were put out by the colonial governments themselves. Usually they were backed by the promise of payment in coin at some future specified date, but "in 1713, Virginia established public tobacco warehouses and issued paper certificates in various denominations for tobacco deposited by the public." The overlords back in London tended to frown on the widespread reliance on paper throughout the colonies, and their attempts to dissuade the practice (and thereby, from the colonists' point of view, to strangle development) were an ongoing source of friction.

The Revolutionary War, when it finally came, was largely financed through a series of paper issues in various denominations that were simply declared "legal tender," with the promise of redemption in coin at some (significantly) unspecified later date and with no backing whatsoever at the time of issuance (future tax revenues, it was hoped, would eventually subsidize the scheme). These certificates, which were known as Continentals, may have been necessary for the success of the Revolution, but almost immediately thereafter they spiraled into near worthlessness (hence the contemporary saying that "a wagonload of money would scarcely purchase a wag-

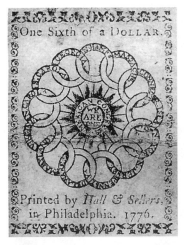

Bill for one-sixth of a dollar (1776). Revolutionary tender.

onload of provisions"), thereby wreaking havoc on the young country's economy. One of the side effects was serious exploitation and dispossession of farmers, many of whom had borne the actual brunt of the fighting as Revolutionary troops (for which they'd been paid in paper), by urban merchants and landlords who started foreclosing on their farms. The resultant series of farmers' uprisings, such as Shay's Rebellion (1786), in turn spooked the merchants and the more secure landed gentry into convening the Constitutional Convention in 1787. The document they in turn produced restricted the right of coinage to the federal government, and forbade both state and federal governments from issuing paper money.

The Constitution did not, however, prohibit private issues, and banks (institutions that, incidentally, had been pretty much illegal under British administration) now rose to the challenge and opportunity and began issuing paper. The situation in the United States during its first four score and seven years sounds pretty chaotic. Legal money took the form of gold and silver coins, but the actual day-to-day circulation consisted in the paper issue of the various independent state and local banks. These paper bills were denominated in dollars, with the promise of redemption in coin, and yet not all banks, not all promises, were considered equally reliable. Thus, in much the same way that exchange rates today regulate trade between various national currencies (dollars into lire into francs into yen and so forth, in constantly changing configurations), in those days exchange rates were established

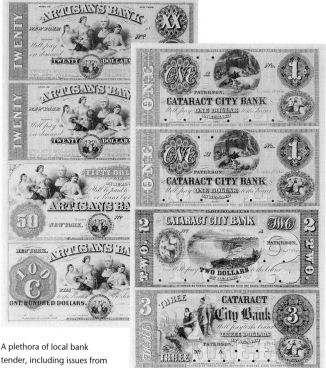

A plethora of local bank tender, including issues from the Artisan's Bank of New York City and the Cataract City Bank of Paterson, New Jersey (1850s)

among the various banks' issues, so that one bank's dollar might only be worth eighty-five cents in another bank's currency. According to DeCoster, "In principle the exchange or discount rate was based on the assets and reliability of the issuing bank, but rates were in effect often determined by the distance of the issuing bank from New York." Robert Krulwich had told me a story about the considerable complications the Illinois rube Abraham Lincoln faced in trying to find some way of paying for his son's schooling back in Exeter, New Hampshire, as no East Coast–based bank would honor any of the checks drawn on his Illinois bank's account. (Come

to think of it, that almost sounds as bad as the situation at some New York banks today.)

Hundreds of state and local banks were issuing their own scrip, but they were not the only source of money. There were in addition thousands of counterfeiters faking all these various sorts of scrip and, in more enterprising cases, simply creating entirely fictitious issues out of whole cloth. "When guides for detecting bogus bills were published," writes De-Coster, "the counterfeiters faked the guides to the advantage of the spurious issues."[4]

The Civil War changed everything. In order to finance the fighting, the governments of both sides began issuing paper money. The Confederacy simply did it, but the Union had to finesse its way around its Constitutional prohibitions by in-

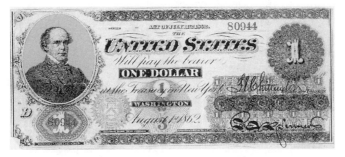

Civil War tender: among the first of the U.S. greenbacks, hand-signed (1862)

voking the emergency situation. The bills the U.S. federal government began issuing in 1861, technically known as Demand Notes, were more popularly known, owing to their appearance, as "greenbacks." The first issue, of sixty million dollars, was mass-produced through engraving; serial numbers were then individually stamped on the certificates, and then they were all *hand-signed!* As Robert Friedberg notes in

4. Of course, the problem of counterfeiture is limited neither to the past nor exclusively to money. A recent piece in the *New York Times Magazine* (July 5, 1998) quoted columnist Vicky Krupka, who monitors the problem of bogus teddy bears for

the standard reference book *Paper Money of the United States:* "The first plates made for the various denominations had blank spaces for two signatures, and below these spaces were engraved 'Register of the Treasury' and 'Treasurer of the United States.' These two busy and important Treasury officials obviously could not sit down and personally autograph several million notes. Therefore a large staff of clerks from the Treasury Department was employed to sign their own names for the two officials. The way the plates were worded made it necessary for these clerks to write also the words 'for the' in addition to their own names."

The National Bank Act of 1864 hastened the demise of state banks and the standardization of circulating currency. Banks were allowed to obtain national charters (the first one to do so in each locality became the First National Bank of, say, Wichita, the second one the Second National Bank, and so forth). These privately owned banks were allowed to issue paper, but the notes themselves were printed by the government and were uniform in design, except for the prominently engraved name of each separate bank. Meanwhile, the battles before the Supreme Court following the Civil War regarding the constitutionality of the federal paper, the greenbacks (Lincoln's Treasury secretary Salmon Chase who'd issued them in the first place, now, in 1870, as chief justice of the Supreme Court, spoke for the majority in declaring them unconstitutional and then dissented vigorously the next year when a new majority declared them constitutional after all), prefigured three decades of extreme social and political conflict regarding the proper character of the nation's currencies. Some insisted on exclusive gold backing (and no printing of paper without such backing); others favored silver backing as well (so-called bimetallism). Many of the same issues first broached in Shay's Rebellion now resurfaced with the Pop-

the Beanie Mom Web site, to the effect that, "At first the counterfeits were easy to spot because the quality was so low. But every time we tell the public what clues to look for, the counterfeiters correct their mistakes and make better-looking fakes. These guys are fast."

ulist movement, which pitted farmers and laborers against bankers and the large trusts.

Throughout this period, polemicists continually wrestled with the notion of paper money as phantasm, as fantasy—indeed, as a specifically *artistic* fallacy. During the 1870s, for example, David Wells composed an anti-greenback tract entitled *Robinson Crusoe's Money*, in which, as a sort of satirical cautionary tale, he traced the natural history of money on an imaginary island. Soon after the introduction of paper currency to the island, Wells reported that the inhabitants took to employing "a competent artist, with a full supply of paints and brushes, and when any destitute person applied for clothing, they painted upon his person every thing he desired in way of clothing of the finest and most fashionable patterns, from top boots to collars, and from blue sallow-tailed coats to embroidered neckties, with jewelry and fancy buttons to match." Twenty years later, when Wells's tract was reprinted as part of the anti-silver campaign, it featured an accompanying illustration by the great cartoonist Thomas Nast. Nast's

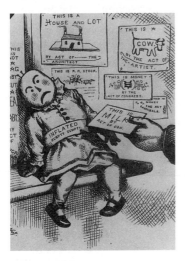

Thomas Nast, *Milk-Tickets for Babies, in Place of Milk* (1876)

drawing consisted of a rag doll propped against a wall, though a message scrawled on the wall asserted, "This is not a Rag Baby but a Real Baby by Act of Congress." A hand from off to the side extended into the picture offering the doll a chit of paper upon which was printed "This is Milk by Act of Congress." Onto the wall behind the doll was tacked a drawing of a cow with the heading "This is a Cow by the Act of the Artist."

Silver coinage became the main issue of the 1896

election, culminating in Democratic candidate William Jennings Bryan's ringing challenge, "We will answer this demand for a gold standard by saying to them, "You shall not press down upon the brow of labor this crown of thorns, you shall not crucify mankind upon a cross of gold.'" Bryan lost, but with time, so did the gold standard.

In 1913, Congress established the Federal Reserve System, which, though retaining a regional emphasis, gradually evolved into a central bank and unified the currency of the nation. Ironically, Lincoln's old Treasury secretary Salmon Chase now found himself being posthumously honored for his repudiation of the greenbacks he'd launched by having his visage affixed to their largest single denomination, the $10,000 bill. The separate local bank issues were standardized, by 1928, into bills that began to look like the ones we use today (the ones Boggs has mastered). In 1933 all forms of currency—gold certificates, silver certificates, bank notes, federal notes, and so forth—were declared interchangeable. Just before the Second World War, the possibility of redemption in gold was canceled, and silver redemption (the possibility of exchanging bills for progressively less pure silver dollars) was likewise suspended after 1968. In 1972, the United States suspended gold payments against international accounts, thereby severing the last connection between paper and metal. We trusted in God.

And all of this history, in a sense, was resonant from the moment Boggs first took his pen to paper.

— —

Jackson Pollock is said to have settled his drink bills with paintings (the lucky bartender!), and Kurt Schwitters merrily included everyday receipts in his collages (*Merzbilder*, he called them, those framed jumbles, a word he derived from *Commerz*, the German word for commerce). Boggs is by no means the first artist to have stumbled upon these precincts. Picasso, the story is told, used to go out shopping: he'd sign his checks and then dash off smart little doodles on the

backs—the checks were seldom cashed. (So that Picasso truly *was* the modern Midas.) Years later, the Swedish artist Carl Fredrik Reuterswärd made a three-dimensional bronze of Picasso's signature, stood it on a tottering pedestal, and titled it *The Great Fetish*. He also printed stretched-out versions of Salvador Dalí's signature and sold them by the centimeter. Marcel Duchamp went to his dentist one day, couldn't pay or didn't want to, and instead drew an ornate check, filled it in

Marcel Duchamp, *Tzanck Check,* Paris, 3 December 1919

and signed it, and the dentist accepted. (Years later, when Jurgen Harten was trying to procure the check for inclusion in his "Money" show, the Italian dealer who then owned it demanded $3,000 just for the loan.)

The mad artist-brut Adolf Wölfi, holed up in a Bern asylum for schizophrenics for the last thirty-five years of his life (he died in 1930), did a series of large, wild drawings of bill-like entities, covered over with elaborate calculations and tabulations: endlessly he kept his delusional accounts. Years later, the Swiss artist Daniel Spoerri (born in 1930) opened his checkbook and wrote out a series of checks, payable to cash at ten Deutsche marks each, and sold them as art for twenty Deutsche marks apiece. ("In exchanging art for money," he explained, "we exchange one abstraction for another.") Timm Ulrichs, a young German artist, went to court and had his name declared a trademark. On March 1, 1971, Pieter Engels

went on life-long strike as a visual artist and proposed that the Dutch government pay him twenty-five million florins for a stone marker ("a visualization") commemorating the ongoing event.

In 1923, during Germany's terrifying bout with hyperinflation, a Munich cabaret artist named Karl Valentin papered over a park bench with worthless 100,000-Deutsche-mark notes. The German word for bench is *bank* and he called his piece *Deutsche Bank*. (My grandmother, who lived through those days, used to tell amazing stories. She described, for instance, how café waiters would take your order on improvised pads of stapled-together 100,000-Deutsche-mark notes: the bills literally weren't worth the paper they were printed on; it would have cost the establishment more to buy fresh pads than to bundle the used notes.) Yves Klein used gold leaf in some of his monochrome series, which in turn gave him the idea for his *Immaterielles*. Accompanied by a collector, he'd take a small glass box filled with gold flakes to the bank of the

Karl Valentin, *Deutsche Bank* (1923)

Arman [Armand Fernandez], *Venus aux dollars* (1970)

Seine, open the box, and toss the flakes to the wind. The collector would gain "possession" of the piece by purchasing the receipt for the gold at face value, plus a minor profit for the artist.

Larry Rivers created a famous sequence of paintings based on slapdash renditions of French money, which in turn features engraved versions of Jacques-Louis David's portrait of the dashing young Napoleon (this around the time that Jasper Johns was painting his American flag—both artists bringing expressionist energy to bear on the flattest of surfaces and imagery). Andy Warhol, early on, created a silk screen that consisted of a sheet of two-dollar bills, as if fresh off the presses. The French artist Arman filled a transparent polyester mannequin torso with suspended dollar bills and called her *Venus*. In 1969, the artist Les Levine purchased five hundred common shares of Cassette Cartridge corporation at 4 3/4 dollars per share. As he declared in the press release that accompanied (and, in a, sense, *was*) his piece, "After a period of one year, or at any time which it is deemed profitable prior to that, the Cassette Cartridge shares will be resold. The profit or loss of the transaction will become the work of art." Robert Morris, as his contribution to that year's "Anti-Illusion" show at the Whitney Museum, undertook a more convoluted but less risky transaction, which he titled *Money*. He arranged for the Whitney to solicit a $100,000 loan, at 5 percent interest for the duration of the show, from a stockbroker-collector; that money was in turn invested in the Whitney's name and at a 5 percent return, with the Morgan Guarantee Trust. At the

conclusion of the show, the Whitney withdrew the money and interest from the bank and returned all of it to the collector, who then made a tax-deductible contribution to the museum in the amount of the 5 percent interest, which the museum then paid to Morris for having come up with the whole brilliant scheme. All of this was documented on the walls of the museum during the show in the form of the three-way exchange of letters in which it had all been agreed to in advance. Rafael Ferrer, as his contribution to the same show, spread out fifteen large cakes of melting ice strewn with autumn leaves and declared, Klein-like, "If anyone complains that it's not collectible art, I'll send them the bill for the ice as a drawing." The art critic Jean Lipman chronicled these and other similar efforts in an article in the January-February 1970 issue of *Art in America* entitled "Money for Money's Sake." She celebrated the ingenuity of such artists in addressing "the old problem of support for the artist," but concluded with the wan hope that such "frank, pure money transaction works will allow artists to retire while still young and inventive, perhaps to take up a hobby in their creative middle years, something fresh like painting or sculpture."

Ed Kienholz took up watercolors. Soon after he'd achieved fame and notoriety through his remarkable assemblage tableaus, in the late sixties, he undertook a series in which he'd spread two strokes of washed-out color horizontally across a piece of quality paper; then he'd smudge in a thumbprint and sign his name; and then he'd get out an old-fashioned stencil kit and stencil between the bands of color the name of some object or other that he desired: "For A TAP AND DIE SET"; "For TWO GOOD MOUNTAIN HORSES"; "For A NEW OVEN AND RANGE"; "For ONNASH'S MERCEDES." To his astonishment, people would happily trade him such things for the opportunity to own an original Kienholz. Indeed, that's how he came to furnish much of his then-new home in Hope, Idaho. But he soon realized that objects by themselves didn't answer all his needs. He still needed some pocket cash, so he started a new series: *For $1.00; For $2.00; For $3.00*; and so forth, on up through

Edward Kienholz, *The Commercial No. 3* (1972, detail)

For $10,000.00—which he proceeded to sell in sequence, after having distributed the first several pieces to his family. As he observed at the time with evident delight, he'd transformed himself into a mint. (Each collector who bought into the series could assume that he or she was pretty much guaranteed at least a ninety-nine cent profit from the outset: once you bought *For $425.00*, all of the pieces in the series bought up to that point immediately became worth at least $425.99, since the next cheapest watercolor on sale from Kienholz directly was *For $426.00*.) Presently Kienholz prepared a brash comparative panel: under the heading "Their Brand X" he mounted samples of each of the denominations of regular U.S. currency; under the heading "Better Brand Y" he mounted some of his own offerings.

Barton Benes, a Manhattan artist, has for some time been deploying old, used paper bills, fresh from the Fed's shredding machines (sometimes procuring millions of former dollars' worth at a time), as the principal medium in his collages and sculptures. "Money is cheaper than art supplies," he once

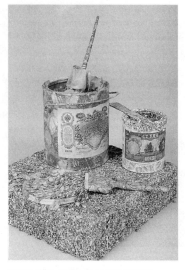

Barton Lidice Benes, *Kroner Blue* (1986)

told the *Wall Street Journal's* Meg Cox. "Paint can cost ten or twenty dollars a tube, but you can tear just a few dollars and make a piece."

As his contribution to Project '74, a major exhibition celebrating the 150th anniversary of the Wallraf-Richartz Museum in Cologne under the banner "Art Remains Art," the American artist Hans Haacke presented an elegantly framed color-photo reproduction of Edouard Manet's *Bunch of Asparagus*, flanked by a procession of ten densely researched panels laying out the social and economic positions of each of the successive owners of the painting over the years, and the prices they had paid for it. The penultimate panel credited the painting's recent acquisition by the Wallraf-Richartz Museum to the work of the chairman of its Friends of the Museum committee, the noted financier and collector Hermann J. Abs, who, Haacke revealed, had had a decidedly checkered past under the Third Reich (he'd headed the foreign division of the Deutsche Bank and served the Nazis on various industrial councils). Perhaps not surprisingly, the trustees of the museum rejected Haacke's offering, provoking a scandal which could well have gone under the banner slogan "Art Remains Politics."

Earlier in the 1970s, during a time of stringent military repression and wide-ranging media censorship in Brazil, the artist Cildo Meireles launched an at-that-time anonymous project, titled "Insertions into Ideological Circuits," in which he momentarily extracted paper bills from circulation, stenciled political slogans and contraband news accounts on their

faces, and then reintroduced them into the circulatory stream. (In a sly homage to the contemporaneous pop tradition, he did the same thing with Coke bottles, printing slogans and dispatches on the pale-greenish glass in a white ink that proved virtually invisible when he returned the bottles for deposit but presently divulged its secret subversive message when the recycled bottles, emerging from the bottling plant, had once again been filled up with their dark drink.)

As early as the 1960s, Elaine Sturtevant, the elder stateswoman of the so-called "image appropriation" movement, began unabashedly lifting imagery from the work of such contemporary masters as Duchamp, Warhol, Stella, Lichtenstein, and Oldenburg—making virtually identical copies of their paintings and serenely signing them with her own name. Some of her models, such as Oldenburg, did not take kindly to the gesture; Warhol, on the other hand, not only welcomed it but even lent her his silk screens to copy. Paradoxically, in recent years the prices on Sturtevant works have been going up in tandem with those of the original works they ape. Meanwhile, a new generation of younger artists has taken to aping Sturtevant herself, after a fashion. Sherrie Levine's recent show at Mary Boone included a series of pieces entitled *Untitled (after Alexander Rodchenko)* which consisted of elegantly framed photographs of photographs by Rodchenko, the great early twentieth-century Soviet avant-gardist. Levine's pieces were selling for a handsome sum, although Mary Boone herself declined to divulge specifics. "I frankly don't see what price has to do with it," she insisted, when pressed. "I just don't come at art that way."[5]

5. The preceding survey, current as of 1988, could easily be supplemented with countless more recent examples—money has hardly lost its capacity to inflame the artistic imagination. In 1996, for example, the Harlem master David Hammons cracked open a charming

David Hammons, *Two Obvious* (1996)

So that, yes, Boggs was by no means first to stumble upon these precincts. Although he'd known relatively little about most of these other sorts of work before he got started with his own drawings, he'd been hearing of them with some regularity ever since. Far from feeling threatened, he seems positively to celebrate each new instance. At least, he did every time I brought some new precursor, uncovered in my researches at the library, to his attention. This was partly because he needed all the precedents he could muster as he prepared for his coming trial at the Old Bailey. But it was largely because he was authentically fascinated by the issues such works raised—fascinated and still at something of a loss himself as to the ultimate significance and meaning of his own work.

Furthermore, for all the similarities, there were profound differences. Most of these other kinds of work had focussed principally on internal issues of art and money: how money

Pierre Alechinsky, *Revalorisation* (C) (1990)

pink piggy bank to reveal the trove of cowrie shells stuffed inside. A few years later, a young pretender named Robin Charles Clark, wielding a meticulous razor, scraped all the pigment off a sequence of dollar bills, eventually displaying the resultant pile of fifty albino bills alongside slim glass vials containing the pigments, painstakingly separated out, which had once made them up. One of the most confounding such instances was a 1990 series of aesthetical-financial interventions contrived by the Belgian master Pierre Alechinsky. Under the title "Revalorisation," Alechinsky scribbled India-ink doodles across the faces of several ornate, long-defaulted Russian Imperial bonds. The joke here, of course, was that Alechinsky was "revalorising" those bonds at the very moment that, on the one hand, the post-perestroika Soviet regime was publicly contemplating honoring those defaulted bonds after all, while, on the other, the art market itself had utterly collapsed. Hence, in fact, Alechinsky might have been doubly *devalorising* those pieces of paper, except that that paradox *in itself* (and for that matter its mention here in this context) might well be serving to *re*-revalorise the works in question. Go figure.

Charles Simonds, *Street-Side Ruins, rue de Cascades, Paris* (1975). Simonds at work.

skews the workings of the art world, how fame skews money, what people value in art and how they express that value, and so forth. Boggs's work, by contrast, was chiefly about the world outside galleries and museums: his work takes place at a three-way intersection, that of art, money, and the everyday world. If anything, a more apt sort of precursor to Boggs's vocation might be found in that of the young Charles Simonds, back in the early seventies, when that artist set up shop, as it were, on the sidewalks of dilapidated neighborhoods and fashioned his miniature-brick archeofantastical ruins in the hollowed-out flanks of crumbling tenements. Simonds would invariably draw a crowd of onlookers, but he'd leave the question hanging as to just what sort of activity was going on—art? play? madness?—and indeed that confusion was part of what the work was about. In a similar sort of way, Boggs is engaged in philosophical disruptions, in provoking brief, momentary tears in the ordinarily seamless fabric of taken-for-granted mundanity. The people he addresses (at least those he involves in the early stages of his enactments) are cruising along on automatic pilot—hey,

he confronts them, Wake up, wake up, look down there, what's holding this thing up, there are no visible means of support, how is it that we fly at all?

— —

Anyway, most of those days before the spree I spent at the library, reading up on art and money. Occasionally I'd head back to my office and place a few calls. I reached Boggs's landlord, Ted Gardiner, at his manor in Compton-Dando, outside Bristol, England. "Ah, yes," Gardiner admitted jovially, "I once accepted Stephen's drawing in lieu of rent." I asked him why. "Well," he said, "for two reasons. First, he had no money, and second, because I figured, who knows, perhaps some day in the future it will be worth something, maybe even more than the rent. I mean, Stephen is a tremendous character and we're all quite fond of him. He has an old head on his shoulders: he's packed a lot into his young years. He's a bit frustrating to have as a tenant, though. I've never been able to get a rent increase out of him. His rent is two-hundred and fifty pounds a month, in Hampstead, and it's been that way for five years. He simply ignores my letters." I asked him whether he intended to make a custom of accepting drawings. "Well," he said, "that's the thing, isn't it? I mean, landlords are landlords and tenants are tenants, and landlords can't get fat and ugly unless tenants pay their rents, so . . ." His voice trailed off. "As time goes along, I suppose, to collect the odd one or two pieces wouldn't hurt." I asked Gardiner what he'd done with his drawing. "I've got it resting quiet right here in the safe in my study." Not on the wall? "Oh, you see, the trouble is, when you live in a house that dates back to the sixteen-hundreds, it's rather difficult to hang modern art."

I called Boggs's mother in Tampa. She was most open and forthcoming, told me stories of his youth—about his Alice Cooper phase, for instance, when no makeup was safe in the house, and about other early intimations of his artistic calling. "One week the walls of his bedroom were a pristine white,

and the next week every inch of the walls was covered with designs and patterns and shapes—all in Day-Glo paint. Including the ceiling. The first time he went away, his dad and I put four coats of white paint on the walls and ceiling. The Day-Glo bled through every coat. In desperation we paneled the walls. But the ceiling art still shows through." She was quiet for a moment. "Perhaps we shouldn't have painted over the walls."

She spoke of her son with great fondness, with high regard and mild concern over his future. She told me that when it came to recollections, she preferred writing to talking, and she promised she would write if any further anecdotes occurred to her. The next day, an eleven-page letter arrived, express mail, brimming with stories. My favorite concerned an early incident: "We two were living just south of Tampa when he was five. Some forbidden fruit had been denied and, Boggs being Boggs even then, he decided to run away. I watched as he packed a little suitcase and went up the dirt road toward the highway. I jumped in my car. I found him on the dual highway, on the median strip, thumb stuck out, heading north. I pulled over and shouted, 'Where ya going, buddy? I'm just going up the road a piece, but hop in.' He crawled in. I drove about a mile to the local supermarket and told him this was as far as I was going. He didn't get out. I said, 'Look, buddy, this is really as far as I'm going, so you'll just have to get another ride, whatever your name is.' 'Ahh,' he said in a whisper, 'you know me. I'm your son.'"

And I called Rudy Demenga in Basel, who proved a true enthusiast. I asked him how he'd met Boggs. "I discovered Boggs at the Hippodrome discotheque in London, and immediately I *knew*." Knew what? "Genius." How? "I smelled. I can smell genius." How? "Moved. How he moved. He was just like an Indian when he is going to catch a wild animal." What was he doing? "He was looking for a girl to dance with. I was touched by him. I asked the lady at my table, Who he is? She said he's an artist. The next day I went by the booth of his gallery at the art fair. I saw his big painting of the pound note,

and the way he had packed so many things into it, I could see that I was right about him. I invited him to come to the Basel art fair. I told him I wanted him to draw Swiss bank notes. Through currency you can criticize the whole government and culture of a country. It's good for artists to change the world."

I asked Demenga how he would describe Boggs. "He looks like an American Indian, but with a white face. He is like a sports athlete, he weighs not one gram too much. Each time there are young girls, they fall in love to him. He is always busy. He is a brilliant mathematician. He knows what is one and one—that is, at the higher level."

Demenga's account of Boggs's Basel stay elaborated on Boggs's own. "One day he went to a local department store and bought an Indian tent with a drawing of an Indian tent. The next day Boggs was going to the Venice Biennale. Since all the hotels were occupied, he took that tent along with him. He tried to buy a rail ticket at the Basel station with his money drawing, but they wouldn't take it. Then he drew a drawing of the ticket itself, and they wouldn't take that either. This was virtually his first serious rejection here in Switzerland and he came back to the gallery dejected. He asked to borrow the money. One does end up borrowing him a lot of money. In Venice he slept in his tent, but from what I understand, for him Italy was no Switzerland."

Demenga related how Boggs then went back to England and resumed work there. "On the first of November, I went to England to see his new show," Demenga recalled. "I remember the day because that was when we had that catastrophe here in Basel with the fire and the chemical spill into the Rhine. Anyway, at the tax-free shop at the airport I bought a gift for Boggs, sort of a briefcase with inside lots of chocolates in the shape and wrapping of one-thousand-Swiss-franc bills—it looked like a million francs in chocolate. I arrived in London and went to the gallery and it was amazing, all the Boggses had been removed and there were little notices 'Confiscated by Scotland Yard.' Boggs came up, and when he saw

my present he shouted, 'Oh Rudy, you brought the bail money!'"

— —

New York was no Basel either, or so I discovered on the day of our spree. We were heading West on Houston, toward I Tre Merli, the Soho restaurant, with Boggs carrying his bulging satchel. "A weird thing happened to me yesterday," he commented. "I was being interviewed by a critic for one of the minor journals around town and he intimated that if I'd give him a drawing he'd give me a good write-up. It was like he was asking for a drawing of a bribe. When I said no, he said that was okay, he was just testing me. Which was also weird, that I'd proved my integrity by not drawing a bribe."

Once at the restaurant, we ordered some salads, and I mentioned how the place's Italian fare reminded me of Boggs's Italian junket. "Yeah," Boggs said. "Italy was about the worst place I've been so far. Hardly anyone would take my drawings. In Milan, once, I offered this waiter a drawing and he said no, I'd used the wrong kind of paper and mine didn't have this special kind of thread running through it like the regular Italian lire do. But then he told me confidentially that I could get the right sort of paper at such-and-such a place and that I could fake the thread in such-and-such a way, and that if I did all that, he would be happy to take my bills, because he thought the drawing was pretty good. In other words, he wouldn't take the drawing as a drawing, but he would have taken it as a counterfeit."

Boggs was silent for a moment and then said, "So, listen, do you have a twenty-dollar bill I can borrow a second?" As I checked my wallet, he reached into his satchel, pulled out his pad, and extracted a superb rendition of a twenty-dollar bill. "Thanks," he said, grabbing the one I'd come up with. "I need it as the model." Reaching back into his satchel, he pulled out a precision green pen. "This is a Koh-I-Noor pen with an incredibly fine tip—point thirteen millimeters. Thing's so deli-

cate it can only stand a few hours of Boggs treatment. In fact,
I've got to get another one today. I go through dozens of
these, both green and black, at nine dollars apiece. And the
paper costs three dollars a large sheet, and what with all the
mistakes and the rejects, I end up extracting maybe two or
three finished drawings per sheet. It costs me a goddamn for-
tune to draw these bills."

He looked over at my twenty-dollar bill and then carefully
transposed its serial number onto the appropriate spot on the
lower left-hand side of his drawing: B22613726F. He re-
peated the process on the upper right-hand side, dropping a
digit. Then he asked me if I had a five and a ten—I did. He
borrowed those and used them as the models for the two
more drawings that he now pulled out of his pad. He then
took a black pen and carefully squeezed in, along the narrow
blank border at the top of each of my bills, the printed anno-
tation: "The Model. NYC. NY. 20.8.87. J. S. G. Boggs." He
then signed his name and returned the money to me, saying,
"There. You can't spend them anymore though, because
they've become part of the art, they're part of the transac-
tion." Whereupon he smiled. There was a sense, whenever
one hung around Boggs, of being continually subject to im-
minent contamination with aesthetic perplex. Grudgingly, I
folded the bills and slid them into a special, separate compart-
ment of my wallet.

He now continued with the final touches on his drawings.
On one of them, in place of the minuscule letter and number
code in the lower right-hand quadrant of the bill, which, he
explained, normally indicated the serial number of the precise
plate from which the particular bill had been drawn (B43I, for
instance, or R72), he wrote E MC2. On another, he wrote
LSD. To the other side of one of the bills he carefully printed
the proviso "This note is legal tender for artists." On one of
the others he wrote, "This note is legal and tender for all." I
noticed that in place of the phrase "Federal Reserve Note" at
the top of his bills, he'd written "Federal Reserve Not." And
down at the bottom, where one might normally find the sig-
nature of the Secretary of the Treasury, he'd substituted his

own above the label, "Secretary of Conception." Indeed, although on first glance his drawings appeared identical to their models, closer inspection revealed that virtually every detail had been slightly skewed.

The waiter brought over our salads and admired the drawings. Boggs turned the drawings over on their blank backs, scribbled "*Lucrum Cessans*," signed his name, and set them aside . "*Lucrum Cessans?*" I asked. "Yeah," he said, "it's a Latin phrase meaning, roughly, 'loss of profit.' In the early days of banking, there were religious prohibitions against interest on loans. But gradually people came to realize that in giving over money, you're also giving up the use of that money for a period. In those days they'd offer the example of a cow. If I lend you my cow and you give it back to me a year later, you're giving me back the same cow, but I've lost a year's worth of milk and now I'm getting a year-older cow. For that reason, it was argued, by analogy, that I ought to have the right to charge interest . Otherwise, *lucrum cessans*, I'm foregoing my profit. When I write '*lucrum cessans*' on the back of my drawings, it's because anyone who accepts them is in fact profiting from my loss."

Boggs ate a bite of salad and continued. "It's one of the important aspects of my work. I never spend a drawing unless I'm convinced it's actually worth at least three or four times the face value at which I spend it. There was one guy who wanted to enter into this big transaction—it's a long story, but basically he wanted me to draw four one-thousand-dollar bills for something I really wanted. But he wanted the drawings almost immediately, he wouldn't give me time to do them adequately. So I just said no."

Boggs took a few more bites. "The thing about the cows and interest reminds me of this true story I once heard about some agronomist estate manager in Africa somewhere who reproached some of the tribesmen on his estate for wasting their time and resources feeding and sheltering some old sick cows. 'Look, Master,' one of the tribesmen replied, pulling two paper bills from his pouch. Paper money was new in this area at the time. 'Here's two pound notes, right? One of them

is old and crumpled, and the other's new. But they're both worth a pound. It's the same with cows.'"

That in turn reminded me of an anthropological story Krulwich had told me about an old tribesman who tried to explain to his son about how last year's cow had been magically transformed at the town market into the coin rattling about in his safebox.

The waiter brought over our bill. Boggs offered the twenty-dollar drawing. The waiter clearly loved it, but he explained that he was only a waiter and as such had no authority to make such a judgment. He suggested we speak with the manager and went to fetch her. She, too, came over, was also clearly taken with it, but likewise explained that she had no authority, this sort of judgment was the owner's exclusive domain, and he wasn't around. This sort of response—the claim, as it were, of lack of standing, the claim that one didn't even have the right to an opinion—came up repeatedly in different forms as we proceeded through our day. Indeed, in the little Museum of the Natural History of Reactions that I was forging in my mind, I ended up giving it a whole wing.

I picked up the tab and we headed out. Boggs dived into a photo store and tried to buy some film with his five-dollar drawing. The Hispanic woman at the register smiled and excused herself, "We're just a chain here." Down the street, Boggs tried to buy a can of Coke at a tiny deli. "No," came the curt reply, "I don't *need* that."

We wandered over to Utrecht's art supply store: Boggs needed to get another pen. "Last year when I was in town," Boggs said, "I pulled off a nifty transaction in there. I bought a ninety-nine-cent pad of green paper with a drawing of a green one-dollar bill." We walked into the store, and at first the signs were auspicious: on the wall behind the cash register was a double-size blowup of a ten-dollar bill, taped, for no apparent reason, to the wall. Boggs found his pen, approached the young man at the register, handed him the pen, pulled out his ten-dollar drawing, and politely launched into his spiel (Boggs is always extremely courteous when he's delivering his spiel): "Hello, I'm an artist and I draw money. This is a draw-

ing. I did it with my own hand. It's not an etching, I drew this. It took me a long time to do. And now I've used up my pen, and I'd like to buy this one. I was wondering whether you'd honor my drawing at face value. It's not legal tender, but it's obviously worth something, and I've arbitrarily assigned it the price of its face value." The guy behind the counter literally blushed scarlet. "Part of my art," Boggs continued, evenly and congenially, "is that I have to spend my drawings." The guy blew up: "You're pushing your luck there, buddy," he almost shouted. "I don't think the federal government would be too happy with this." Boggs was unfazed: "Don't you think it's worth something?" "Look," came the reply, "we're not in the business of appraising worth here. I'm sure it's worth something but—I'm an artist myself, and let me tell you, if I could get away with paying for my supplies with drawings of money, believe me, I'd draw hundreds of them." "You think so?" Now Boggs began to lose his cool. "You know how long it took me to draw this thing? I bet you couldn't get through two." Whereupon he left the pen at the register and marched out with his drawing.

It was remarkable how electric the room had become the moment Boggs pulled out his drawing. Not just the clerk—his colleagues, the other people in the store, everybody seemed to become hypercharged. This almost always happens, although sometimes the tension gets defused in nervous humor and usually Boggs remains serenely detached amidst the crackle. I was reminded of sociologist Erving Goffman's famous observation: "To walk, to cross a road, to utter a complete sentence, to wear long pants, to tie one's shoes, to add a column of figures—all the routines that allow the individual unthinking competent performances were attained through an acquisition process whose early stages were negotiated in a cold sweat." Boggs throws us back on first things.

We wandered over to the Strand Bookstore. Boggs had to leave his satchel with a guard at the entry but he pulled out his pad and took it along. "Got your bill with you?" I asked. "Sure," he said, nodding toward his pad. "I always carry my wallet." He browsed for a few moments, selected a book, took

it up to the counter, made his way toward the front of the line, and went into his rap. A smile began to break over the cashier's face, but otherwise he didn't say a word. "Don't you think it's worth ten dollars?" Boggs pressed. "Next!" announced the cashier.

We moved on and drifted into Washington Square Park. "Maybe I should try to buy some drugs with a drawing," Boggs said. "You know, purely as a transaction." He thought about it for a moment. "Nah," he said, "I'm in enough trouble."

We made our way toward the arch. "It's funny though," he continued, "how these transactions are themselves a lot like drug deals. The same sorts of questions come up: Is it real? Is it a con? Is it good stuff? Is it worth it? Is it legal?"

Boggs pulled another pad out of his satchel and showed me a recent drawing of an eight ball on a pool table. "Do you like that drawing?" he asked. It's okay, I said. "Do you think it's worth anything?" Yeah, I said, to the person who wants it. "Finding that person is tremendously difficult."

We started up Fifth and came upon one of those pushcart hot-dog stands. "Want a hot dog?" Boggs asked, as we approached the stout, middle-aged vendor-lady. He did his rap, The lady gazed on, only gradually comprehending. "I from Romania," she finally said, haltingly. "My boss, he want . . . he expects . . . look." She reached into a side panel and pulled out a price list; she then counted out five soda cans on her cart top, pointed to the soda price, and tapped it five times, gesturing toward her cash box. She smiled, "But it good . . . you talented." She patted Boggs's arm in encouragement. "Too bad we didn't have any cartons of Kents," Boggs commented as we walked on.

We walked past a vitrine that featured sign-making materials and signs ("No Trespassing," "Sorry, We're Closed," "Have a Nice Day," and so forth). "Wait a second," Boggs said. "I want to check this out." Inside there were signs of every sort, and numbers. Boggs considered a panel displaying three-dimensional wooden numbers. The sales clerk came over, a friendly kid with a hearty Brooklyn accent. "How

much are these numbers?" Boggs asked. "Dollar seventy-nine each." "Tell you what," Boggs explained. "I want to get a 2 and a 3, and I want to buy them with this *drawing* of a five." He then proceeded into his rap. The sign vendor seemed impressed. He took the drawing in hand, gave it a good long look. "Very nice," he said. "Very nice. From far away you couldn't even tell. Beautiful. I could never do that. I praise you on your artistic work. But I'm not the manager. I could never take it." Boggs suggested he could buy it himself and reimburse the cash register. "But what would I do with it?" the clerk asked. "What would I do with it? If it were bigger, I'd frame it. But that size, my friends would just think I had a five-dollar bill on my wall. They'd think it was strange. And anyway, if I were going to frame something, I'd frame a real five-dollar bill." Couldn't argue with that logic, and Boggs didn't even try. "*That* was interesting," he said, as we walked down the street and into Barnes and Noble.

Boggs browsed in the financial section. "See," he said, "in a transaction like this, I'm not looking for a book to read but rather for one that will look good as part of an eventual framed set. Like this one here"—he reached for a volume entitled *Economics in One Lesson*—"but I don't like the colors on its cover. Or this one here"—a book called *Beyond Our Means* with a burning hundred-dollar bill on its cover—"but it's too expensive. No, I guess I'll try this one." He reached for the paperback of *Indecent Exposure*, with a handwritten check as the illustration on the cover and a price tag of $3.95, and headed for the checkout lines. Only, rather quickly he was faced with a conundrum, for the sign above one register read CASH ONLY, while the others were labeled CASH OR CHARGE. By no means sure which applied, he eventually settled on one of the charge lanes because it had the shortest line. Once at the front of it, he performed his set speech. The young lady behind the register stiffened mildly and then said, "Probably not. Not here anyway, although you can try one of the other registers." He went to the next register, produced his five-dollar drawing, and repeated his speech. This cashier looked dubious. "Do you at least like the drawing?" he asked. "No,"

she replied. "Oh," he said, "I must be in the wrong line." He moved to the next lane and tried once more. By this time business had more or less come to a standstill and the five cashiers were convening as a committee. He went through his spiel once again, and this time the cashier was silent. "Do you think it's worth five dollars?" he asked. "No," she said, "I think it's worth more than five dollars." "Will you take it then?" he asked hopefully. "No," she replied. "We take real money here." At that point Boggs gave up and went to return the book to the stacks. "Hey, artist!" the remaining cashier shouted after him. "You forgot me!" So he returned to her (she was the one behind the CASH ONLY line) and he did his rap one more time, and this lady just started laughing. "Remember that girl that used to work here who came from that college upstate where they give them too much fresh air?" she asked her colleagues. "She'd have taken it. Girl was real smart about books but she had *no common sense.*" Boggs gave up, returned the book, and then cheerfully bid the girls a good afternoon, leaving a veritable symposium in his wake.

— —

Back on the street, we figured maybe the problem was the neighborhood, so we decided to try uptown a ways. We hailed a taxi to the Algonquin (the cabdriver spoke not a word of English and even Boggs couldn't bridge the linguistic gulf—I wonder what the poor guy told his wife that night about the weird offer somebody made him that day). The man behind the Algonquin bar explained he had no authority and suggested we talk to the manager. The manager in turn considered the offer, pocketed the five-dollar drawing, and summarily ordered the bartender to fix the man a drink. Simple as that. Boggs explained how he'd need the change and a receipt, and now the manager balked. "I'm offering you a drink in exchange for your drawing," the manager insisted. "What's the problem?" Boggs explained the problem and the deal fell through. "That often happens," Boggs told me as we walked.

"People often defer because they lack authority. But those in middle authority often jump at the opportunity, particularly when they have some sort of carte blanche open tab and aren't paying themselves. But they just can't deal with the business of the change and the receipt, so the deal falls through."

We headed thirstily on. We crossed Sixth Avenue diagonally and headed toward Forty-seventh Street Photo (located paradoxically on Forty-fifth Street), a place known around the neighborhood as Yeshivah Stereo, owing to the full-line electronics store's exclusively Orthodox Jewish staff. Boggs spotted a worthy potential purchase, a four-dollar bottle labeled SOLUTION (photographic solution). "A bottle of the solution would look good as part of one of the transactions, don't you think?" Boggs commented, as he went over to the cashiers. There, two bearded gentlemen considered him sagely as he delivered his spiel. They carefully looked the five-dollar bill over and another couple of younger fellows came by. They all entered into a disputation, partly in English, partly in highly spirited Yiddish. The problem, it appeared, was that of the prohibition against graven images. "You see," explained one of the bearded cashiers, "Abraham Lincoln as money—it's borderline, but we can take that. The question is whether or not it would be *treyf* to hang a *picture* of Abraham Lincoln." "You hang pictures of the rebbe," one of the younger scholars pointed out. "Yeah, precisely," replied the other, "but Lincoln's no rebbe. No, this is definitely *treyf*." At that point, an old middle-manager type drifted over, looked in on the minyan, saw the drawing, and his eyes almost bulged. He snatched the drawing out of the cashier's hands and went racing with it to the back of the store. Boggs looked over at me incredulously, but I didn't have a clue. For a while I thought the old guy had gone to call the cops or something. He was gone for five, ten minutes, and showed no sign of coming back. "Does this mean you're accepting the drawing?" Boggs asked one of the bearded cashiers, who simply shrugged. I noticed that one by one all of the salespeople seemed to be drifting to the back of the store: there was a regular party going on back there. Fi-

nally the middle manager re-emerged—the very picture of decorum—returned the drawing, and pronounced very solemnly that no, they definitely could not take this.

From there we drifted over toward the real Forty-seventh Street, where we wandered among the booths in the gold and jewelry bazaars. "That," Boggs suddenly exclaimed, thunderstruck, "*that* I've got to have." He was gazing into a low showcase at a small, flat, rectangular gold pendant stamped with the face of a one-hundred-dollar bill, on sale for thirty-seven dollars. Boggs asked the booth manager whether he'd take thirty-four, and he pulled out his three drawings. "I suppose so," said the salesman before Boggs even had a chance to go into his routine. As Boggs now proceeded with it, the fellow gave the drawings a more careful inspection. "Now I can see it," he said. "A second look and I can see that they're not genuine. A talented fellow like you should be doing something more positive." Boggs explained how he had to have that pendant, it was important to his art. "Well then," the salesman proposed, "go out on the street, sell your drawings, and bring me back the money. We only take money here. See the problem with these is, I take them and then when I want to give them to a lady over there to buy something, she won't accept them. Maybe you should try an antique shop."

Boggs tried a few more stalls before dejectedly abandoning his pendant fixation. "I've got to get a drink," he said, as we hit the street. "There's one bar we could go to uptown a ways where I know I could spend one of these drawings," Boggs said. "The bartender up there loves them. He has told me he'll accept as many as I care to offer. But that's not what this work's about, to do it over and over just to be doing it. His mind's not being challenged anymore, he's not learning anything." A few blocks uptown we entered a bar. The young waitress took our order. Boggs requested separate checks. "So," he said, "you're beginning to see. It's not as easy as it sounds. It takes me ten hours to draw one of these things, and then another ten to spend it. And then the thing I buy I usually can't use because I have to save it for the final piece, and I can't use the change either." Why do you do it, I asked. "Be-

cause there's a lot I still don't understand about these transactions. Whenever I get the feeling I've understood, I know that just means I'm not pushing hard enough, I have to push harder, to find new ways. I know my work reflects something, resonates with something in society, but I'm not clear what. I often view my work as the symptom, but I don't know the disease."

I asked him why he thought he'd become an artist. "Oh that," he said. "I've come to believe that sort of thing is eighty-twenty. Eighty percent you're born with it and stuck with it and you have no choice. That leaves you just a 20 percent chance of escaping your fate as a child—and I guess I just didn't make it." What in his childhood had prevented him from escaping? "I don't know," he said, but the question set him to talking about his early days. "When I was two my mother ran away to join a traveling carnival and she took me along with her. From two to five we traveled up and down the Eastern seaboard with the carnival. My best friends were the giant and the bearded lady and the spider man. The guy she was with ran several concessions. We had the Deep Sea Adventure trailer, which was just a bunch of aquariums on the inside with the best stuff in the tank outside to draw the people in. I was making change by the age of three. Hell, I knew how to shortchange by the age of four. That last is a joke. Don't write that down. Seriously, just a joke."

Boggs began to relax again, telling tales of his carny youth. The day's dejection fell away. "There was this Wild Man of Borneo show. What they'd do, they'd dig a wide rectangular trench about six feet deep, surround it with four feet of chain-link fence, pitch a tent up over the whole thing, and then put all these exotic posters up outside the tent. They'd toss snakes and chickens and lizards and frogs and tarantulas into the trench, all of which they'd cart from place to place in boxes. They had normal snakes, and they'd take a box of rattlesnake rattles and sew them on their tails. Then they'd take real old de-fanged rattlers and they'd throw them in, too. They'd scatter bones all over the bottom. Then they'd get this guy and dress him all up. He was supposed to be from Borneo, so

he should have been black, but this was the late fifties and that
sort of thing was pretty sensitive, so instead they got this pa-
thetic old white drunkard and they stained him with berry
juice and they put him in the pit and charged folks fifteen
cents to get into the tent and watch him go wild, snarling and
yelling and throwing the snakes all around. Between shows,
he was just a drunk. One day the Wild Man of Borneo went
into town and got so drunk he forgot where he was, and he
started to perform his act in a bar. They threw him in jail, and
suddenly there was no Wild Man of Borneo for the evening
show. So instead they had the Wild Boy of Borneo—they
stained me with the berry juice and dressed me up and put me
into the pit . . . My mother happened to be away that evening,
and when she came back and found out, she was really furi-
ous. But actually, I loved it.

"I loved all of those things. I loved the Gorilla Man, which
was a show where this man would turn into a gorilla right be-
fore the audience's eyes—every quarter hour on the quarter
hour. The way they did it was with a pane of glass running
through the cage at a forty-five-degree angle between the
man in the gorilla suit and the audience in the bleachers. As
the show began, it was completely dark on the gorilla man's
side and a bright spotlight shone down on this other guy in
regular street clothes just off stage. His image was reflected in
the glass and you couldn't see the gorilla man at all. Little by
little the light on the regular guy went down as the spotlight
rose on the man in the gorilla suit behind the pane of glass. So
that before the audience's eyes the regular man seemed to be
turning into a gorilla. And then silently, invisibly, the glass
pane was retracted, and now the gorilla man pounced toward
the front of the cage, tore it away, and went bounding into the
audience, utterly clearing the tent in thirty seconds. The guy
who thought up that act was a carnival genius. Because the
problem with carnival acts was always the milling-about after-
ward: people took too long in clearing the tent; it slowed
things up for the next show. But with this act, not only did
you clear the tent instantaneously, but you created such an

impression outside that people immediately started lining up to see what all the commotion had been about.

"You know the strongman with the barbells?" Boggs asked. "That was another nice act. The audience would drift in and there on this metal platform would be resting the barbell with these huge black iron spheres prominently labeled 1000 LBS each. The strongman would come out and challenge any one from the audience to try and lift the barbell. Invariably some macho stud would rise to the challenge and fail miserably, whereupon he'd confidently announce that the feat was impossible. He was no plant—you could always count on somebody from every audience to play that role. But anyway, then our strongman would stroll over and with a huge heave and gargantuan exertions, he'd somehow manage to lift the sucker. Worked every time. The people backstage just had to remember to turn off the electromagnets under the platform."

Boggs was quiet for a moment, savoring the memories. "One time I'd decided I was going to get a tattoo. I was about four. The tattoo guy told me sure, he'd do it, and then he went into this real shtick, telling me all about the needles and the blood and the pain and so forth, all in wonderfully gory detail, and I squirmed off the chair and said, 'Actually, maybe tomorrow.' That same evening I took a walk outside the carnival grounds, and I came upon an abandoned campfire. I thought it was out. It was so unspeakably beautiful, so delicate, those dainty little cakes of white ash leaning one against the other. They were so lovely I just wanted to take one home to show my mom, and I reached over to pick it up. Turned out they were white-hot coals. I screamed in agony and went running back to the carnival. I was okay, but I learned something. I learned that outside the carnival, just as in it, things weren't necessarily what they seemed.

"But anyway," he continued, "the thing is that traveling with the carnival, the towns we'd visit always seemed utterly vapid by comparison with the life inside the carnival. And when we left the carnival, after I was five, and settled in

Tampa, school was just incredibly boring. If I'd had a 20 per-
cent chance of escaping my artistic fate, I'd lost it by then."

The waitress came over with the bill and she and Boggs
got into a nice and easy bantering conversation. Boggs pulled
out his five-dollar drawing and offered it to her, and she said
she really liked it but that the bar wouldn't take it and she
couldn't possibly afford to. "Oh come on," Boggs said, "Just
five dollars?" She explained that she was a struggling actress
herself and that sometimes she didn't even clear nine dollars a
night in tips. "Oh well," he said. "Thanks anyway." And I
picked up the tab.

Outside on the street again, Boggs commented, "Too bad.
It's a shame: if she'd just taken it, somebody would probably
have come along in a few days and offered her five *hundred*
dollars for it. And she could obviously have used the money."
It occurred to me that Boggs was operating a sort of floating
aesthetical-ethical crap game. Or else a sort of fairy-tale
virtue test, in which the worthy agreed to sacrifice and were
subsequently rewarded a hundredfold.

It was past four-thirty now, and Boggs said he had an idea.
We walked up to the Museum of Modern Art and got into the
admission line. Adult tickets were five dollars apiece, and on
reaching the front of the line, Boggs pulled out his drawing
and gave his rap. The girl seemed flustered. "I can't take
that," she said. "But it's art, and this is an art museum," Boggs
replied commonsensically. "I know," she said, "but for me to
be able to accept that, they'd have to convene a full meeting
of the board of directors. Those are the people who make all
the decisions on acquisitions." Boggs gave her his meltingest
hangdog expression. "Listen," she proposed confidentially,
"it's four-forty-five right now and this is Thursday. Come
back in fifteen minutes and you're allowed to pay whatever
you wish."

That sounded promising, but to pass the time, we crossed
the street over to the Crafts Museum, where Boggs again
tried to use his five-dollar drawing for an admission ticket.
The fellow there wasn't nearly so friendly as Boggs was laying

out his spiel. "Look," he finally said gruffly. "I'm a painter, so you're talking to the wrong guy about the value of art."

We meandered around for a few minutes and then returned to the Modern; it was now just past five. Boggs approached the same cashier and once again presented his drawing. "I don't want your drawing," she said in exasperation. "You can give me anything you want, give me a penny, and then I can let you in." "I know," said Boggs, "that's why I'm giving you this." She looked at him for a moment, looked to her sides, and then quickly punched 0.01 into her register and gave him the receipt, returning the drawing. "There," she said, "now get going."

Boggs just shrugged his shoulders. "Can't give it away," he said. We pretty much decided to give up for the day. We made our way back outside and then on toward Sixth Avenue. Along the way we passed a young Haitian street vendor who was selling exuberant paintings of Caribbean street scenes—black women strutting down the street balancing baskets on their heads, young men hoeing bountiful vegetable gardens or dancing their hearts out, jungle beasts peering lasciviously from behind the foliage. INVEST IN THE FUTURE read a little sign the vender had propped up along the wall. FRANCIS PARAISON. ORIGINAL PAINTINGS. Almost as an afterthought, Boggs inquired if he had any paintings for sale at twenty dollars. "Sure," Paraison said, "those over there." Boggs picked one of them up, a colorful village scene. Boggs asked if he would take nineteen dollars. "Suppose so," Paraison replied. Boggs reached into his satchel and extracted his twenty-dollar drawing.

"Would you take this?" Boggs asked.

Paraison looked at it for a few moments, a wide smile breaking over his face. "Absolutely," he said. "Absolutely, I'll take that."

— —

The actual transaction took a surprisingly long time to complete. For the next fifteen minutes Boggs was engaged in an

almost frenzied ritual of documentation. He got the one-dol-
lar change from Paraison and then had him draw up a receipt
on a sheet of scrap paper. Meanwhile, he took the dollar bill,
squeezed into its upper border the printed words "The
Change" and an abbreviated summary of the transaction, and
then he dated and signed it and set it aside in a special enve-
lope. He borrowed his own drawing back for a moment and
on its blank backside he likewise annotated details of the
transaction—date, location, Paraison's name and address, and
the serial number of the bill that he was giving in change. He
then took Paraison's receipt and similarly annotated that, in-
cluding the serial number of his own drawing, and then he
slid that into his envelope as well. Paraison seemed bemused
but tolerant. "It's a good drawing," he said. Boggs now went
on to annotate the back of the painting. He then double-
checked all the annotations and, satisfied, he returned his
twenty-dollar drawing to its new owner and bid him a
friendly good evening.

As we walked away, I commented how the obsession with
documentation among conceptual artists—those most imma-
terial, seemingly least bureaucratic creators—had always
amused me. I cited the way Lucy Lippard a while back had
been able to put together a several-hundred page chronologi-
cal sourcebook entitled *Six Years: The Dematerialization of the
Art Object from 1966 to 1972*, as if the art object's simple dis-
appearance could not be allowed to remain standing as simple
mute testimony to itself. Boggs responded that the documen-
tation in his own case didn't really arise out of that sort of im-
pulse. "No," he said, "what my documentation is about is the
fact that the transaction itself is the art object. This particular
one, incidentally, was a rather pretty one, didn't you think?
An exchange of artworks on the curb outside the Museum of
Modern Art. But now its components, for the time being at
least, are becoming scattered. He has the drawing and I have
the change, and these are both very specific objects. If the
piece is ever to be reassembled, only those two specific enti-
ties, with their specific serial numbers, and then the various
other components—all of them cross-annotated with each

other—will be able to do the trick. The transaction itself thus becomes a unique object."

Boggs explained that he would now keep mum about the transaction for the next day but that thereafter he would begin contacting dealers and collectors about its existence. It had been a full day, and following the momentary excitement of the successful transaction, we both realized how exhausted we'd become. So we decided to pack it in.

During the next several days I kept up regular telephone contact with Boggs. He related how he was eventually able to spend the five-dollar drawing on a six-pack of beer in Greenpoint and the ten-dollar drawing on lunch at a small sandwich shop in Soho. He'd also accomplished a fifty-dollar transaction with a downtown video store. He was currently negotiating "a major, really major" transaction that he'd tell me more about when next we met.

Meanwhile, I received a call one evening from a young woman with an English accent who introduced herself as Helen Traversi, an independent art dealer. She explained that she was here from London working on behalf of certain collector clients and trying to track down, among other things, money drawings by Boggs. She was just confirming that I still had the models for the three drawings from my spree with him, which I did. She told me she might be getting back to me about them but that for the time being she was particularly interested in tracking down the drawings proper. As far as she'd been able to determine from her investigations, including conversations with Boggs himself, he had spent at least fourteen drawings during his current stay in New York, and she'd already been able to buy several of them back. She told me she'd gone over to the curbside outside the Modern earlier that day and located Paraison, but that the Haitian artist had refused each of her increasingly ample offers: he simply didn't want to part with his Boggs.

The next day I went over to the Modern to talk with Paraison, and sure enough, there he was, hawking his paintings. He broke into a broad smile as I approached. "You again," he said, reaching for my hand. "Yeah, everybody want to know

about that drawing. Yesterday a lady come by, offer me a lot of money. But what for should I sell it? I like it. Several hundred, a thousand dollars, what can I buy with that? Some food that then it's gone?" He reached into his back pocket and pulled out his wallet: he kept the drawing neatly folded among the other bills, right there in his wallet! "Here I have the idea. And I *like* this idea. It's a good idea." Paraison paused. "I almost lost it the other day, though," he said. "My little boy reached in and took it for ice cream money, and I only just noticed as he was heading out the door."

— —

A few days later, at another midtown bar, while recounting a recent hundred-dollar transaction with the artist Christo, Boggs reached into his satchel and extracted an envelope containing the eighty dollars he'd received in change, all neatly annotated. It turned out that Boggs was carrying all sorts of recent transactions in that satchel. Presently, he pulled out a candy box covered with money wrapping. As he opened it, I was expecting to see Demenga's chocolate bail, but instead there were dozens, scores, of actual ten-dollar bills inside. "This is an ongoing piece I'm working on," Boggs said. "It's almost finished. I started with a hundred new, consecutively numbered actual one-dollar bills. I signed them all, and have been offering them for sale at ten dollars apiece. Each time somebody buys one, I annotate the date and the place and the name of the purchaser on the ten-dollar bill I receive in payment—I stipulate that payment be in the form of a ten-dollar bill—and when I finish I'm going to frame the hundred ten-dollar bills as one half of a diptych, the other half of which will obviously be scattered all over the world." So that box contained almost a thousand dollars.

Then, after rummaging around, Boggs pulled out an actual thousand-dollar bill and an actual five-hundred-dollar bill (Presidents Cleveland and McKinley respectively), both antiques encased in separate Lucite frames, along with two exquisite drawings that he'd made using the two framed bills as

models. He explained that the big transaction he'd been working up and was about to pull off involved trading these two drawings for a three-dimensional holographic portrait of himself holding up a British pound note. "I want to be able to show the British court what an actual reproduction of a pound note looks like," he explained. Actually, he had talked the portraitist down from her standard fee of fifteen hundred dollars to $1,499, so that he could get a dollar in change. He'd rented the Lucite-encased models from a local coin store for a week at the standard rate of fifty dollars. (He'd had to rent antiques, for, as he explained, the Treasury no longer issued such bills. Partly in an effort to foil drug pushers, the highest denomination that currently circulates is the hundred-dollar bill.) He now pulled out a fifty-dollar drawing with which he was hoping to pay the rental fee. "This is going to be a really beautiful transaction when it's finished," he said. "Wheels within wheels!"

I asked Boggs whether he wasn't concerned to be traipsing around with so much money. "Nah," he said. "I don't look like the sort of person who would be carrying anything worth stealing. In fact, if anything, I look like the mugger, not the muggee." That was true, as far as it went. But it also occurred to me that in a strange sort of way, all of that cash was no longer really money for Boggs. He no longer thought of it in those terms. Once he'd signed and annotated a bill, he figured he'd taken it out of circulation, rendering it a mere component in an arcane artistic project that nobody except for him and a few collectors could possibly find of any interest.

He recounted how he'd been working very hard to develop a technique for *erasing* dollar bills. "It takes a lot of time—*a lot of time*—and it's been a trial-and-error process, but I've just about perfected a method whereby I can efface the inks on a bill and get it down to blank paper. I've got a variety of ideas as to what I might do with that. For instance, take an uncut sheet of thirty-two virgin one-dollar bills, erase one of them, and then draw it back in. Or else, entirely erase both sides of a one-hundred-dollar bill and then try to sell the blank paper for one hundred dollars—which would be an interesting

transaction in itself, but might also make a nice homage to Rauschenberg who once erased a de Kooning drawing and claimed the blank sheet of paper as his own of art.

"I'd also like to create my own unit of currency, the Bogg, print up a series, and then study its price fluctuations." Boggs went on to point out that one company in England called De la Rue's actually designs and engraves currency for over one hundred of the world's countries. "You know how I feel about the technical quality of the printing work on most currency as opposed to that on most art," Boggs said. "What I'd really like to do is to print an edition of my own money with De la Rue's. But for the time being I'm enjoined from doing so. In the wake of my arrest, there's literally an injunction forbidding anyone at De la Rue's from so much as talking to me."

— —

At this point I asked Boggs about that arrest. We'd mentioned it so often in passing, but, seriously, what on earth had happened there? And what was this upcoming trial going to be all about?

"Back in August 1986," Boggs began with a sigh, "after I'd come back from Switzerland, the *Daily Telegraph* ran a piece on my success there, and as a sort of postscript their legal correspondent was asked for his opinion, and he suggested that in England anyway I might be in violation of Section 18 of the 1981 Forgery and Counterfeiting Act, which makes it an

J. S. G. Boggs's drawing of a Bank of England fifty-pound note

offense for anyone, without written permission from the Bank of England, to—I believe I've memorized the phrase now—'reproduce, on any substance whatsoever, and whether or not to the correct scale, any British currency note,' or some such.

"Anyway, after that article came out, I wrote a letter to Mr. Robin Leigh-Pemberton, the Governor of the Bank of England—this was in early September—asking him for permission to go on drawing my likenesses of British currency. He passed my letter on to his deputy, a Mr. Gordon Edridge, who, late in September, wrote back denying permission, telling me what I was doing was illegal and that I was risking confiscation and arrest. *He hadn't even seen the work!* I wrote back once more, enclosing slides, acknowledging that this was an unusual case but insisting that mine was a serious artistic endeavor deserving of serious attention. He wrote back, denying permission once again. I called him and tried to ex-

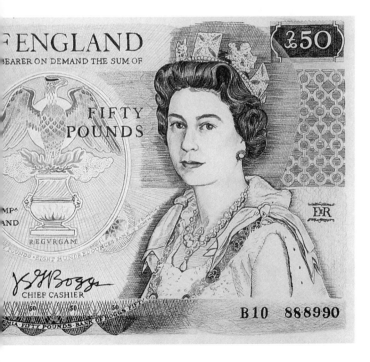

plain things, but he was adamant and in fact very intimidating. He told me I was risking the full might of the Bank of England.

"At that point I decided I'd better engage a solicitor. I went to a young fellow who specializes in art law—his father was an artist, and he represents the Picasso and Matisse estates and all sorts of others. His name is Mark Stephens, his partner's name is Roslyn Innocent (of all things), and their firm is called Stephens-Innocent. Anyway I engaged him, and as a retainer I offered him as much as I could afford at the time, which was a check on my account at Midland Bank made out to the sum of one millionth of a pound. He was a good sport: he accepted. And he told me that he really doubted the Bank of England would actually do anything.

"On Friday, October thirty-first, of last year—Halloween —I was in a small independent gallery called the Young Unknowns where I was helping set up my contributions to a group show on the theme of money. Other artists were involved, too, but mine was the work where the image of the pound note was most directly quoted. Actually I was going to be having two shows—that one and another in the lobby of my own branch office of the Midland Bank in Hampstead, which was going to be opening the following Monday. I was figuring, hell, I'll do the shows and somebody from the Bank of England will drop by and see that I'm not threatening anyone and they'll let the issue pass.

"Instead, that afternoon, I was there at the gallery, being interviewed by a television crew from BBC-1, when suddenly three big guys, two in suits and one dressed more casually, barged in and immediately started throwing orders around. The regularly dressed guy—his name was Reg, he identified himself as a detective from New Scotland Yard—shouted in a voice like thunder rolling down a mountain: 'Turn that camera off now!' They expelled the film crew—of course, there were protests all around. Then the three guys started taking things off the wall, my things and other people's things, although, interestingly, they decided to leave some of the more overtly political works. 'Let's not get involved in that,' they

said to each other. They stuffed all this stuff into a big black bag. I was speechless. Peter Sylveire, the gallery director, was going crazy: 'You can't do this! freedom of speech! freedom of expression! a private establishment!' and so forth. All this took about half an hour. Then they came over to me and said, 'Are you Stephen Boggs?' I said yes. 'You're under arrest.' Part of me wanted to laugh, but it was also pretty scary, what with the firmness in their voices: they were taking this whole thing very seriously. 'We're taking you to the station.' They led me outside and stuffed me in the car, Peter in hot pursuit, yelling, 'You can't do this, don't be crazy!'

"So there we were, cruising along in this unmarked Ford Sierra, with them engaged in nonstop interrogation all the way to the station: 'So, you thought you could get away with it? How many have you made? When did you make them? Where did you make them? Who were your accomplices? Why don't you tell us now and save us a lot of trouble?' I was starting to panic. 'Look, I just want to talk to my counsel. Please, sir, may I, please, sir?' 'So your counsel told you to keep quiet. Why don't you just . . .' and so forth."

They delivered Boggs to the station, read him his rights, frisked him, and removed his belt and comb ("So you won't try to commit suicide by hanging yourself or slitting your wrist"). They continued to question him and he continued to ask them to please call his solicitors. "Reg said, 'Okay, who's your solicitor?' and I said, 'Stephens-Innocent.' Reg became furious: 'Lock him up if he's going to be a smartass.' They threw me in a little cement cube with a thick steel door with a little grated slot in the middle. No windows, a plank of wood for a mattress. Some time passed and then the slot opened and Reg was there asking, 'So, did you decide to cooperate?' 'Please,' I said, call my solicitors, the firm's name is Stephens-Innocent, I'm not trying to be a smartass.' But Reg just slammed the slot shut. He wouldn't believe me, and things were really getting scary. Nobody knew where I was."

Finally, the second time they opened the grate, Boggs was able to persuade them to look up the firm's name in the phone book, and they were eventually able to track down Mark

Stephens, who promised he'd be right over. In the meantime, the police were examining the evidence. "At one point Reg came back, opened the door, and said, 'Hey, need a blanket or a cigarette? Listen, me and the boys have been looking at your work. It's actually pretty good. How much do you sell it for?' I couldn't tell if that was a trick question, although Reg definitely seemed to have softened. 'I'm really sorry,' I said, 'but I want to talk to my solicitor.'"

Stephens showed up around nine and told his client he didn't have to talk to these people. They told him they were going to go search his apartment, with or without his permission. He told them to go ahead, he hadn't done anything wrong. The interrogation now resumed, with Stephens as a sort of referee. "They were talking crime," Boggs recalls, "and I was talking art. It was kind of a hilarious conversation. 'Look,' I said, 'If I drew you a picture of a horse, would you try to put a real saddle on it?'"[6] Little by little, the Scotland Yard boys began to lose their enthusiasm for the case. Their leader—"Chief Inspector Davies: this wasn't just some bobby; they'd sent some chief inspector, top-of-the-line brass to supervise in my apprehension"—looked over at his colleagues and wondered out loud, "What should we do with him?" Gradually they came to the conclusion that as far as New Scotland Yard was concerned, they were set to drop charges. They called the Bank of England and informed them so, and then released Boggs to the custody of his solicitor, with a warning that he not try to flee the country. It was around midnight.

6. Back in the 1870s, in the anti-Greenback tract *Robinson Crusoe's Money* discussed earlier, David Wells argued that to imagine that paper money might supplement or replace precious metals was to succumb "to a mere fiction of speech and a bad use of language," for paper could only represent money; it could no more be money than "a shadow could be the substance, *or the picture of a horse a horse*, or the smell of a good dinner the same as the dinner itself" (italics added). Boggs often drifts into metaphors which turn out to have a rich history in the tradition of American populist and anti-populist rhetoric, though he has no academic grounding in that history (perhaps the spirit of the debate still swirled around the carny encampments of his youth).

The spirit and tenor of that debate were recently reinvoked by Walter Benn Michaels in his fascinating study, *The Gold Standard and the Logic of Naturalism: American Literature at the Turn of the Century.*

Boggs went home to his ransacked studio apartment and collapsed into the arms of his girlfriend. He spent Saturday utterly depleted. Sunday morning arrived and out of habit he went and got the morning papers. To his astonishment, his own name was in the headlines. The *Daily Telegraph* trumpeted ARTIST DEFIES BANK OF ENGLAND AGAIN! and went on to report that his Midland Bank show was set to open the next day. "Too bad that show's never going to happen," Boggs sighed to his girlfriend. All of its pieces had been there in his studio, he had been planning to mount the show late Friday afternoon, and he assumed the police had confiscated them during their search. His girlfriend now informed him that late Friday, at a point when she'd had no idea where he was, she'd just assumed he was being forgetful and she'd gone and mounted the show herself—things had been so hectic since

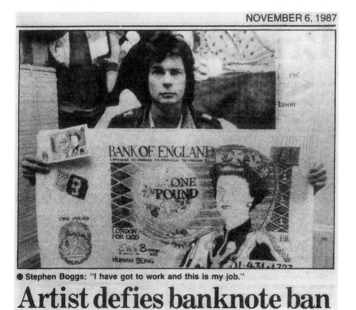

NOVEMBER 6, 1987

● Stephen Boggs: "I have got to work and this is my job."

Artist defies banknote ban

Headline from the *Hampstead and Highgate Press*

that she'd forgotten to tell him. Now he freaked out all over again. He called Stephens and they agreed to meet the next morning at the bank.

The first thing Monday morning, Boggs called the local bank manager to offer his profuse apologies for all the trouble he'd no doubt caused. "I promised him I'd be right over to take the show down," Boggs recalls. "And then the bank manager said, 'You don't need to do that. The Bank of England has already been in touch, and we've talked with our solicitors, and they tell us there's no reason why we shouldn't proceed with the show, which is precisely what we intend to do.' That completely blew me away. I couldn't believe it. I just sank to my knees and started bawling."

Later that morning Stephens met Boggs at the branch bank in an exultant mood. It appeared the Bank of England had been in touch with officials in all of the other countries whose currencies Boggs had been drawing—the Americans, the Swiss, the Italians, the Germans, the Belgians, and the French—trying to put together a coordinated prosecution, and all of the other countries had declined to go along. Notwithstanding which, the Bank of England was remaining firm. Later that afternoon, a somber-faced official arrived, entered the bank, confiscated the one drawing that depicted a denomination of British currency (a twenty-pound note), and left. When Stephens called the Bank of England to find out what was going on, he was informed that "in due course we're going to arrest your client." (In Britain, the Bank of England retains the right to launch a private prosecution, even when other law enforcement agencies have decided against proceeding with a case.) Stephens asked what they meant by "in due course." "As soon as the press dies down," came the reply.

Meanwhile a public furor was developing. Boggs was suddenly a popular hero—people were recognizing him on the street and bidding him good luck. An ad hoc petition campaign was launched, and such luminaries as David Hockney and Gilbert and George signed the statement defending artistic freedom. Another petition was signed by sixty members of Parliament, and one of them, Tony Banks (Labour MP for

Newharn Northeast), organized a show of artworks on money-related themes in the House of Commons itself, under protection of parliamentary privilege.

Undeterred, the Bank of England proceeded with its case, which received its first hearing on April eighth of this year, in the chambers of Stipendiary Magistrate Eric Crowther at the Horseferry Road Court. Boggs was represented by Stephens, and the Bank of England by Robert Harman, Q.C. (the Q.C. stands for Queen's Counsel and connotes a very important personage in the British legal caste system).

"The whole case turned on whether or not I had been engaged in making 'reproductions' of British currency," Boggs recalls. "Now, in art world parlance, the word 'reproduction' has a very specific meaning. It suggests a debased form of image production—one achieved in multiples of some sort. In ordinary usage one says, 'Oh, that's not an original, that's a reproduction.' So, I mean, there's no way that what I was doing was a reproduction. Regular British pound notes are reproductions. I was making original drawings. Seemed obvious to me." Boggs paused for a moment. "Anyway, by the end of the day, the judge announced that he didn't feel competent to rule on the issues raised in the case, and that it should therefore be remanded for consideration by a jury of my peers—'a jury of twelve good men and women and true,' as he put it—and that's what we now have coming up on November twenty-third at the Old Bailey."

— —

During the next few days I found myself conversing with all sorts of lawyers. First off I tried to reach Robert Harman, Q.C., to get the Bank of England's side of the case. I did get through but found him extremely reticent. "I'm afraid I can't speak to you," he apologized. "My lips are sealed. My branch of the profession is very strong about this business of not ventilating the case before trial. I can't help it if the defendant has waived his own right to that silence, but in my own case it might be seen as very unfair for me to get a bite at the cherry,

as it were, before the hearing." I was able, however, to ascertain the lineaments of Harman's position from an article in the English journal the *Law Magazine*, in which Jolyon Jenkins summarized the proceedings at the April prehearing. According to Jenkins, Harman submitted that the term "reproduction," as used in the 1981 act, meant "a copy which is substantially the same as a currency note or any part of it." The Bank of England retained unfettered discretion to grant or refuse permission in cases of such reproduction, so that the only question was whether or not these drawings of Boggs's were reproductions. For Harman, the word "reproduction" needed to be considered consistently with the definition of the term in the copyright law, which is to say an object exhibiting a degree of similarity "sufficient to come so near to the original as to suggest that original to the mind of every person seeing it." Which Boggs's drawings obviously did. So that Boggs was obviously guilty and hence liable for the appropriate penalties.

Mark Stephens was considerably less reticent when I called him. From the outset he agreed with certain aspects of Harman's position. "Look," he said, "everything revolves around the definition of reproduction. 'Reproducing' is what we lawyers call an absolute offense, which is to say, if you've done the act, you've committed the crime. What we're arguing about here is whether Boggs has done the act, whether what he's done is to reproduce. Well, there are ten meanings for the word 'to reproduce' listed in the *Oxford English Dictionary*, and not one of them applies to the facts in this case the way the Bank of England would like it to. We intend to call an editor from the *OED* as one of our witnesses. The word 'reproduce' implies not merely a visual similarity but a functional one as well. Look, if for example I had you over to my house and you were admiring my beautiful Chippendale desk and I offered to make you an exact reproduction of that desk for a thousand pounds, and you accepted that offer and gave me the money, and then a week later I delivered to you a *drawing* of that desk, you'd be quite cross with me. And you'd have a right to be. What Boggs has made, in the same sense, is not

money, it is not redeemable silver or gold or even a nice new note—nor does it claim to be. A bank note represents value, and a Boggs does not, though it *has* value. Boggs does nothing to resolve the category confusion, as it is the very process of his art to mystify, to obscure the distinction itself. But surely it is the function of law to recognize and proclaim such obvious category distinctions."

Out of curiosity I called some American lawyers as well. I tried to get through to the Secret Service's General Counsel, John Kelleher, but his secretary informed me that the Secret Service does not provide advisory opinions, and neither would he. It does, however, provide a form letter on the subject of the legal parameters for reproduction of American currency, and she was happy to send that along to me. According to that memo, the Boggs situation vis-à-vis U.S. law is a decidedly iffy one. The operative sections of the U.S. Code (Sections 474 and 475 of Title 18) mandate prison terms and heavy fines for any person who "makes or executes, in whole or part, after the *similitude*" of any U.S. currency, or who makes "*likenesses*" of such currency. One could easily imagine a Harman-Stephens-type debate on the precise applicability of such words as "make" and "similitude" and "likeness" in the Boggs context.

One of Boggs's New York lawyer friends, Herbert Nass, however doubted there'd ever be occasion for such debate: "The Treasury Department has bigger fish to fry, so I'd be surprised if it ever came to a prosecution here. But then again, I'm flabbergasted things have gotten as far as they have in England. And I know Boggs is very concerned about it. I mean, we can sit here and philosophize and satirize all we want, but the last thing Boggs wants to have to do is to spend the next several years making license plates." Nass paused for a moment. "Not in jail anyway," he added, as an afterthought.

—‑—

Boggs dropped by. He was getting set to return to London to continue preparations for his case. He brought along the

hologram. In the end the holograph-portraitist had dissuaded Boggs from holding up the pound note. Instead, she had portrayed him holding up and looking through an ornate, empty picture frame. The artist framed, perhaps? The way he was holding the frame, at any rate, his hand brought all the way around its long vertical side, made it look eerily like Boggs behind prison bars.

Apropos of nothing in particular, Boggs said, "A lot of people who call themselves artists *are* counterfeits. The Bank of England just got the wrong man." He sighed. "I really don't understand why all this is happening to me," he said. "I don't understand why they feel so threatened, although I must say I like Demenga's comment: 'One fool can ask more questions than a hundred wise men can answer.' So now they're going to send me to my room for forty years."

He smiled wanly, headed out the door and toward the airport, and that was the last I saw of Boggs for several weeks.

J. S. G. Boggs,
Framed (1987,
detail)

William Harnett, *Still Life—Five Dollar Bill* (1877)

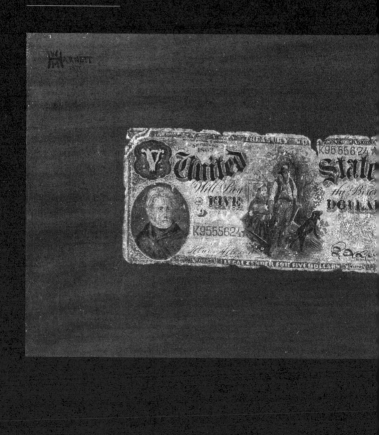

"MORONS IN A HURRY"

[1987]

HAT WAS IN mid-September. Soon after Boggs left, I realized I'd gotten pretty much hooked on the story and would now have to go over to London to cover the trial. I took to calling Boggs for updates at regular intervals. One afternoon I asked him how he was passing his time in anticipation of the trial. "Stephens has me boning up by researching all the earlier instances of artists' taking currencies as their subject matter," he replied. "Actually, as you know, I've been doing some of that all year—that's how I stumbled upon that case of William Harnett."

William Harnett?

"Didn't I tell you about Harnett?" Boggs asked. "It's an incredible coincidence. It turns out that there was this nineteenth-century American artist named Harnett who specialized in trompe-l'oeil canvases and was arrested by the Secret Service in 1886 on charges of counterfeiting, because he'd made four paintings depicting various denominations of dollar bills. There are all kinds of eerie parallels. He was charged with four counts, I was charged with four counts. He was arrested in 1886, I was ar-

rested in 1986. In 1880, he'd gone to live in London; I went to live there in 1980. The date of his arrest was November 23rd—a hundred and one years to the day before the date of my trial. Pretty weird, huh?" Boggs hummed the theme from the *Twilight Zone*, and then continued, "I heard about him from Edward Nygren, the curator of collections at the Corcoran Gallery, in Washington, to whom I'd been referred in the course of my researches. It turns out there was a whole spate of these trompe-l'oeil paintings of dollar bills starting in the eighteen-eighties, and Nygren is one of the world authorities. He, in turn, referred me to Alfred Frankenstein's book *After the Hunt*, which is about Harnett and his contemporaries, and which includes several illustrations. I did a little article about all this for the October issue of *Art & Antiques*. But, really, you should take a look at Frankenstein's book."

— —

I did. During the next few days, I tracked the book down, and I also called Nygren. He sent me a copy of his unpublished monograph called "The Almighty Dollar: Money as a Theme in American Painting." It was true: Boggs had stumbled upon a strange byway in the history of art and money.

The late nineteenth century, I now learned, witnessed the highest triumph of the trompe-l'oeil style of painting which had so absorbed commonsensical American artists and their audiences since Colonial times. Common images included fireplaces whose warmth almost radiated off the canvas, and after-hunt scenes before which one almost felt compelled to reach out and stroke the wet fur on the felled rabbit hanging from the painted hook on the painted wall. In this context, money, a three-dimensional object existing in a shallow space, seemed ideally suited for portrayal. But artists evidently weren't drawn to money—and certainly not so obsessively— for purely formal reasons. Nygren reminds us that money was an obsessional topic throughout the Gilded Age in both political and cultural circles. It was in this period, as we have seen, that the Populists and the robber barons were battling it out

over greenbacks, bimetallism, the gold standard, and so forth. This was also the period, as Nygren points out, when William Dean Howells had one of his characters in *The Rise of Silas Lapham* remark to another, "There's no doubt but money is to the fore now. It is the romance, the poetry of your age. It's the thing that chiefly strikes the imagination." And this was also the period when Theodore Dreiser offered his popular definition of money in *Sister Carrie:* "Something everybody else has and I must get." It was the era of Horatio Alger and the era of Mark Twain.

This was the context in which American artists—William Harnett the first among them—began executing their money paintings. Usually, the image consisted of a single bill, or several bills, tacked to a blank wall like a trophy—though, as Nygren points out, an illusory one. That was the whole idea: you were seduced into reaching for it, and it wasn't there.

Alfred Frankenstein characterized the counterfeiting story as "the van Gogh's ear of the Harnett saga." It was famous in its time and even long after. It seemed to capture the essence of the master—a painter whose technique was so exquisite that he was arrested by the Secret Service for counterfeiting. Under interrogation, it appears, Harnett was asked how many images of money he'd perpetrated, and he confessed to four. He was let off with a warning: he was to cease and desist forthwith and was never to attempt any such images again. And, as far as is known, he never did.

But Harnett's brush with the law appears only to have inflamed the imagination of some of his colleagues: they bridled at the prohibition. Perhaps the most remarkable of Harnett's successors was John Haberle. In 1888, he exhibited at the Art Institute of Chicago a painting entitled *Reproduction* (caveat Boggs!), which consisted of a ten-dollar silver certificate flanked by scraps of newspaper in which one could make out fragments of text: "John Haberle the Counter . . . ceives the eye into the belief that . . ." and "would humbug Barnum." The following year, Haberle exhibited a painting entitled *U.S.A.*, which featured a frayed one-dollar bill portrayed face down in a veritable ecstasy, a delirium of chutzpah, so that the

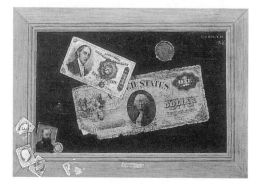

John Haberle,
Imitation (1887)

viewer could read the complete text of the prohibition against
imitation of federal currency which at the time was included
on the backs of all United States bills. There were countless
other instances of the subgenre—works with such provocative
titles as *A Perfect Counterfeit* and *A Bad Counterfeit* and *Time Is
Money,* by such middling masters as N. A. Brooks, J. D. Chal-
fant, F. Danton, Jr., and—my own favorite—Victor Dubreuil.
Sometime after 1896, Dubreuil created a painting entitled
Safe Money, which Nygren was recently able to secure for the
Corcoran's collection; indeed, it was the acquisition of this as-
tonishing piece which launched Nygren on his own art-and-
money passion. *Safe Money* portrays an open safe teeming
with the palpably obscene profits of the North South East and
West Rail Road monopoly, whose abbreviated name graces
the top of the safe; the edge of the painting is the notched,
beveled edge of the open safe itself. That beveled edge has the
effect of a picture frame, so that here, near the beginning of
the twentieth century, Dubreuil seems to have made and pro-
claimed a discovery about the quintessential nature of the art
that was to come. Renaissance artists had posited the thesis
that the picture plane ought to function as a window slotted
into the wall. Dubreuil for his part anticipated the status of art
in the wake of the robber barons' apotheosis, how the picture
plane would thereafter function as a *vault* cut into the wall—
an occasion for the ostentatious display of wealth.

Alfred Frankenstein, after much research, was able to es-

tablish that the Secret Service had not simply gone off half-cocked in its philistine suppression of Harnett. It appears that, unbeknownst to any of these artists, the Secret Service had been trying since 1879 to track a fiendishly accomplished counterfeiter whom it had dubbed Jim the Penman. According to Frankenstein, Jim the Penman did not print his bills but, rather, *drew and painted* them, "with artists' materials, and with a professional artist's imitative skill." In those days, a hundred dollars was worth so much that the effort must have

Victor Dubreuil, *Safe Money* (1896)

seemed worth it. The Secret Service apparently hauled Har-
nett in on the assumption that he might be their man. As it
happens, Jim the Penman wasn't caught until a decade later:
in 1896, he was revealed to be a German immigrant named
Emanuel Ninger, who operated out of Flagtown, New Jersey.[1]
Frankenstein quotes Laurence Dwight Smith's book *Counter-
feiting: Crime against the People* to the effect that Ninger's
notes were considered so remarkable at the time that "there
was public protest after his arrest, subsequent to his passing a
hundred-dollar bill in New York," and "collectors paid high
rates for specimens of his work." Boggs, for his part, comes
down pretty hard on Emanuel Ninger, who in one sense was
the closest to him in technique of all these predecessors. In a
section of his *Art & Antiques* manuscript which that magazine
did not use, Boggs writes, "Jim the Penman stole from peo-
ple, using his talents deceitfully and stupidly. Remember, even
if his works were worth more than face value, which he him-
self did not recognize, he did not give people the opportunity
to appreciate his workmanship. Instead he would leave them
to present the piece to the bank, whereupon it would be con-
fiscated, leaving the party both uncompensated and without
even the novel object to keep as a souvenir."

1. The Secret Service probably derived their "Penman" pen name for Ninger from the
example of the famous Victorian forger James Townsend Savard, who also went by
the name Jim the Penman. Savard's British exploits inspired a novel and a play. They
also appear to have inspired James Joyce, whose *Finnegans Wake* features an authorial
alter ego named Shem the Penman—himself the author of a work entitled *The
Haunted Inkbottle.*

 The Argentine writer Julio Cortázar was also inspired by cases of forgery encoun-
tered in his work as a translator for the United Nations, some of which he describes in
his *Around the Day in Eighty Worlds*; one case is particularly noteworthy: "My strange
(to say the least) visits to Interpol have introduced me to almost alchemical labors, vo-
cations bordering on martyrdom or poetry, beginning with a man who falsified bills of
the maximum denomination (because anything less wouldn't be worth the trouble) by
a procedure that consisted of cutting vertical slices of half a millimeter from two hun-
dred legitimate bills so that their reduction in size would be so slight as to pass unno-
ticed, later to make from the two hundred bills the two hundred and first that repre-
sented his profit."

It's not surprising, perhaps, that these late-nineteenth-century money pieces are enjoying a fresh vogue in this, our own gilded age. Ironically, collectors have to wade through a thicket of false attributions—there are, for instance, countless counterfeit Harnetts—to find the real thing (or, anyway, the purportedly real thing), but, once found, it fetches a good price. In 1899, Haberle's *Imitation*, which portrays a dollar bill and some seventy cents in change, sold for a hundred and seventy dollars. As Lot 81 at Sotheby's May 1987 auction—near the height of the recent run-up in art-world-auction prices—it was estimated that it would continue the symmetry by bringing a maximum in the neighborhood of $170,000. It actually went for $470,000.

In my own brief foray at research into these nineteenth-century figures, incidentally, I came upon one other antecedent for Boggs's situation: the melancholy case of the great American landscape artist Ralph Albert Blakelock. Crushed by the meagerness of his earnings as an artist, he took to manufacturing his own money, million-dollar bills with miniature landscapes and his own portrait in the middle. When he tried to cash one of these bills at a New York bank, he was apprehended and remanded to a mental asylum, where he lived out the remainder of his days.

——

During those weeks before Boggs's trial, while I was studying the relations of money and art and value in the late nineteenth century, something quite remarkable, of course, occurred in the world of contemporary values: the stock market collapsed, with the Dow Jones Industrial Average losing over five hundred points in a single October afternoon, and similar calamities occurring on financial exchanges throughout the world. This catastrophe caused a great deal of anxiety about money and an even greater amount of mystification. (It was just around this time that a homeless New York City woman, who, as it happened, went by the street name of Billie Boggs, was

forcibly removed to a mental hospital for, among other things, indulging in the manifestly insane behavior of burning dollar bills in public; this Boggs, too, went on to become the subject of a celebrated test case.) Experts calculated that almost half a *trillion* dollars in value had disappeared from the American economy overnight—but what had happened to it, one wondered. Where had it gone? One answer was that it hadn't *gone* anywhere; it wasn't now in some new place, where we would eventually be able to locate it if we just set our minds to it. Rather, it had in a sense never existed in the first place. There is always something dreamy about the great speculative frenzies, and, inevitably, at some point the dreamers awake. It was simply, as many commentators now took to noting, morning again in America.

Those whose lives and livelihoods were tied up in the art market observed these developments with considerable alarm. Prices in the art world during the previous half decade had been surging alongside those in the financial markets, and, in many cases, among the same clientele. The new class of young stockbrokers and investment bankers and corporate lawyers and freelance speculators constituted a large proportion of the new players in the art scene, particularly in the contemporary art scene, and dealers and artists and auctioneers cringed at the spectacle of their sudden difficulties. Not only might many of the players now have to absent themselves from the market, at least for the short term, but many of them might well simultaneously have to dump substantial portions of their own collections onto the market as a way of raising quick cash and covering their other losses. The market thus threatened to glut at the very moment that many of its best players were abandoning the field. Or so, anyway, were many interested observers beginning to fear. These trepidations began to congeal around the prospect of the big upcoming contemporary art auctions at Christie's and Sotheby's, scheduled for the first week in November in New York.

I decided to attend one of these galas—the opening night of the Sotheby's sale on November 4—as a way of gauging the

status of the current scene and in turn preparing for that other upcoming spectacle of values-in-contest, the Boggs trial scheduled for later that month in London. The place was thronged with rich folk in formal attire: a friend of mine commented that he'd never seen so many white people in black clothes. It is strange the way people dress up to spend money—or, more precisely, to be *seen* spending money. The wardrobes *were* spectacular—but they could easily have predated the crash. The looks on people's faces, however, were decidedly post-crash. There was a certain forced gaiety in the air, but it barely veiled the air of distractedness, the anxious looking-about, the tightness around lips and eyes, the dry catch in people's voices. A great deal was clearly at stake. No one knew what was going to happen: if a series of lots near the beginning of the auction (de Koonings and Mitchells and Lichtensteins and Heizers and Morleys from the estate of the late dealer Xavier Fourcade) were to fail to meet their reserve (the secret minimum stipulated by the seller), who knew what effect this might have on the subsequent pieces in the sale? The room seemed primed for a chain reaction. (Every failure of confidence, just as every sustaining of confidence, can be said to result from a chain reaction.) Many of the people in the room had big money tied up in their private collections back home, and whether or not they themselves had works up for auction, they seemed edgily aware that at any moment now they might suddenly have wee money tied up in those collections.

But as it happened, that evening, the market held. From the start prices seemed to steady: some a bit higher, some a bit lower than expected, a few shockingly higher, another few disconcertingly lower. It was as if everyone in the room had momentarily agreed to consecrate this space as immune to the laws of gravity wreaking such havoc just beyond its portals. There was a great unspoken agreement: people would continue to bid incredible sums of money for various works on offer (sums equivalent in many cases to several decades' pay for most workers), in part to sustain the value of other

similar works they themselves already owned.[2] That was part
of what was going on, part of why faces loosened tangibly as
the evening progressed, sparkle returning to those previously
veiled gazes. There were, however, other factors also at work.
Prices quoted high in dollars were in fact considerable bar-
gains in Japanese yen or German marks, since one aspect of
Wall Street's crash had been a headlong plummeting in the
dollar's exchange rate. There were a lot of phone bids from
overseas, and translated into many of these currencies, prices
for de Kooning and so forth might actually have been said to
have slid considerably. Beyond that, these particular auctions
were highlighting works by the great, established masters—
de Kooning, Pollock, Dubuffet, Johns, Christo, Hockney,
Stella, and so forth. Investors who'd managed to bail out of
the market in time, before the crash, had plenty of cash that
they now needed to park somewhere, and these sorts of
triple-A rated (as it were) works on paper and canvas could
well have seemed decidedly more secure than some of the
other paper securities on offer these days—stocks, bonds, reg-
ular green bills. (John Russell subsequently wrote in the *New
York Times* of his "depression at the thought of the loud ap-
plause [at these auctions] that greets what is, in effect, a defin-
itive loss of faith in money.") This effect was even more evi-
dent in the transstratospheric prices registered in the ensuing
weeks by such quadruple-A-rated lots as the van Gogh *Irises*,
which fetched a record fifty-three million dollars. Many of
those who were reassured by the steady performance of the
market for established masters still looked with real forebod-
ing toward any upcoming auction which would feature the
until-recently highly prized works of the young phenoms of

2. During the ensuing months this issue of art and money continued to bedevil profes-
sionals in the field. In February 1988 the New York City Department of Consumer
Affairs ordered all galleries to "conspicuously display" the prices of artworks along
with the works themselves. This led to howls of protest from dealers. One of them,
Gerald Stiebel, explained to Douglas McGill of the *New York Times*, "We don't like
the price getting in the way of the enjoyment of the exhibition. Some of the figures
that we ask for things are difficult to comprehend, for us as well as for the public."

the seventies and early eighties. De Kooning and Pollock were one thing, but might the next Schnabel, say, to come up for bid prove the first tear in the bubble?[3]

Boggs's work, of course, addressed precisely these sorts of confusions and anxieties. Why do people place any value whatsoever on certain sorts of configurations on paper, and why do they then suddenly lose their faith in that value? Questions like these were suddenly making people crazy, and one couldn't help wondering what sort of impact that general mood of edginess would have on the upcoming trial.

— —

I next met Boggs a few weeks later at his London gallery, the Young Unknowns, on the south side. On the very eve of his trial, he was defiantly displaying his wares as part of a group show. There were old works, including a piece called *The Banker's Dozen*, which consisted of nine drawings of non-British denominations and signs boldly attesting to the earlier confiscation by Scotland Yard of the four others—pound notes. There was the holographic piece, with its two money drawings, receipt, and Boggs himself, all framed. And there were some new works as well, including a framed drawing of a ten-pound note—only, when you looked closely, you realized that you were looking at a frame surrounding a stretch of wall onto which Boggs had directly drawn the bill, as if to taunt Scotland Yard: "Confiscate *that!*" There was, in addition, a medium-sized black wooden box projecting from the wall and labeled "Safe" (Boggs's homage to Dubreuil?). The box had a glass panel at about eye level through which one could see an actual one-pound note—or, rather, the *reflection* of a one-pound note, for the piece consisted of an internal sequence of angled mirrors which conveyed the image of an actual note

3. And indeed, in the end, prices for such works did crater substantially in the ensuing months. The art market too went into a period of at least temporary decline (or, rather, "adjustment," as the term of art had it), and dozens of galleries were forced to close.

buried in the depths of the box. "Now, *that*," Boggs suggested, "might actually constitute a reproduction of a pound note. So go ahead and arrest me."

I asked Boggs how things were going.

He said he was feeling tense. As it turned out, the prosecution was not going to be seeking a jail sentence after all, only a fine. But the point was moot, because Boggs had resolved—he'd *had* to resolve, to hear him tell it; he had no choice if he was going to safeguard the principle of artistic freedom—that he wasn't going to pay any fine under any circumstances. "I mean, if they fine me I'll draw them the fine," he said. "Then they'll probably fine me for that, and I'll draw that fine, too. But eventually they'll probably rule me in contempt, and that *will* lead to a jail sentence." The prospect seemed both to quicken and to terrify him.

He was, at any rate, quite notorious. The coming trial was receiving a good deal of press coverage, and he was being recognized when he appeared in public. "The other day, I was at the British Museum," he told me. "They currently have up an exhibition of British banknote design through the ages, of all things, and it's got some terrific items, including the actual old portraits that the Bank of England used as models for the etched portraits on the current bills. So just who's copying whom? Anyway, they also have several glass cases filled with wonderful examples of classic, long-abandoned banknotes. I took out my sketching pad and started to draw some of them. Really beautiful things. Suddenly, a woman came over to me and told me I was to cease and desist—it was against the law to draw British currency. I said, 'Oh, yeah?' And anyway these bills were two hundred years old, for God's sake. I ignored her and went back to work. About half an hour later, a big bouncer type came over and said, 'Hello, Mr. Boggs. We're not supposed to be here, are we?' And he proceeded to throw me out. It was as if they'd been expecting me."

As he was being led out, Boggs had managed to pick up a copy of the show's catalogue, and he now pulled it from his satchel. "Here," he said. "Look at this." He turned to a page on which was reproduced George Cruikshank's 1819 cartoon

version of a contemporary British currency note—virtually exact, except that the central image in Cruikshank's rendition consisted of a ghastly line of bodies dangling from an extended gallows, and the "£" had been fashioned out of a noose. The catalogue text explained that in those days counterfeiting was rampant, as was the death penalty as its punishment, and it went on to say, "The system was hard, for it is quite apparent that not only those who actually perpetrated the forgeries risked dire punishment; anyone who handled the counterfeit notes, knowingly or not, stood to suffer just as much." (The text also pointed out how along the left side of his bill Cruikshank had conspicuously printed "Specimen of a Bank Note—not to be imitated.") Boggs acknowledged that,

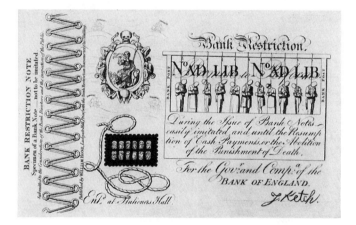

George Cruikshank, *Bank Restriction Note* (1819)

all things considered, he was probably lucky to be testing the limits of the British currency laws at the end of the twentieth century rather than near the beginning of the nineteenth.

The next morning, however, it became clear that, jail sentence or no, the Bank of England was still taking this case very

seriously. Not only had the case been assigned to the Central Criminal Court, the Old Bailey, but it had been assigned to Courtroom No. 1, perhaps the most historic such chamber in England. As journalists and lawyers milling around the ante-chamber beforehand recalled, this was the room in which Dr. Crippen, the infamous wife-murderer, had been tried in 1910; this was the room in which most of the spy cases, the Official Secrets cases, the IRA terrorist cases, the S & M brothel cases, the cases of the Yorkshire Ripper and the Bath Murderer had all been heard. And Boggs was going to be sitting in the very spot that all those vile miscreants had once occupied—news that wasn't doing much to calm his fidgets.

Courtroom No. 1, which is on the second floor of the Old Bailey, opens out on an august hall (green serpentine columns, dark wood paneling and benches, marble parquet floors, elaborate, somewhat kitschy murals above the entry-way to each courtroom). That hall, in turn, opens out on a high central vault, the interior of the cupola whose exterior distinguishes the building on the skyline of the City of London. (The City, of course, is London's financial district: the Bank of England's headquarters are on nearby Threadneedle Street, and the stockbrokerage houses are scattered all around.) The exterior of the Old Bailey's dome was under scaffolding the week I was there: I was told that the gold-plated statue of blindfolded Justice atop the cupola was too heavy and was threatening to come crashing down through the building. Were it to do so, some of the milling journalists and lawyers and prospective jurors now remarked, it would probably take out the mural at the top of the interior vaulting, whose four panels depicted, in compass-point rotation, Truth, Learning, Art, and Labour. "As usual," Boggs noted, "Art is portrayed as opposed to Truth."

The murals above the courtroom doors portrayed various allegorical scenes, the import of which was driven home by weighty mottoes inscribed in elegant lettering underneath: "The Law of the Wise Is a Fountain of Life," for instance, and "Right Lives by Law, and Law Subsists by Power." The motto above the entry to Courtroom No. 1 proclaimed, "Poise

the Cause in Justice Equal Scales" (just like that, with no punctuation), and the mural showed an imperial scene with a panoply of dignitaries and common folk bowing down before dour Justice, her scales suspended at the end of an outstretched arm. It occurred to me that in this standard icon Justice is portrayed as having recourse to a money changer's scales as the device for metaphorically judging the worthiness of competing claims and values. How would Boggs's bills balance off against the real thing in the days ahead?

Presently, the judge in the case preceding Boggs's completed his summation, dispatched his jury, and vacated the room; and the bailiff now came out to look for Boggs. It appeared that Boggs would have to be placed under formal arrest, booked and frisked downstairs, and prepared for a dramatic entry up an interior stairwell that led directly to the dock.

Boggs left with the bailiff, and the rest of us drifted into Courtroom No. 1, which proved to be a large, distinguished wood-paneled space laid out in classic British courtroom style, which in itself bespeaks a whole philosophy not only of justice but also of social roles. The judge's bench and table were on a raised platform beneath a Damoclean sword and a coat of arms; facing that throne, on the other side of the room and at the same level, was the dock—the defendant's chair and desk, which were enclosed by a low, square wooden balustrade. Directly behind the defendant's chair, and within the enclosure, was the flight of stairs leading to the holding cells below. Over to the judge's right and one and two levels below his platform were the jurors' benches; the next level below theirs held the press seats; and then, at the lowest level, in the basin between the judge's and the defendant's plateaus and facing the jurors' escarpment, were the tables for the various defense and prosecution lawyers, the solicitors and barristers.

The solicitors were the ones in street clothes, with the piles of documents on the tables before them; they had handled the earlier phases of the case. The barristers and their assistants wore black robes, little white double bibs (in the style of Cotton Mather), and elegantly coiffed gray wigs; it was they, and they alone, who would argue the case, from their

positions at little podiums by their sides. Robert Harman, Q.C., was serving as the prosecuting barrister. Boggs's solicitor, Stephens, had managed to procure for him the services as barrister of Geoffrey Robertson, a famous advocate of civil liberties and press rights—a sort of British combination of Floyd Abrams (although there is no formal equivalent of our First Amendment in Britain, Robertson has championed such First Amendment–type clients as the *Observer* and the *New Statesman*) and the Harvard lawyer Arthur Miller (as Miller does on PBS, Robertson conducts a popular legal roundtable program on Granada Television). Robertson has also been a frequent advocate before the European Court of Human Rights in Strasbourg (his clients elsewhere have included members of the beleaguered Czech Jazz Section), and, to judge from his comments to the press, he seemed to see the current Boggs proceedings as a necessary, if probably futile, exercise—merely a preliminary to his heart's true desire: an appeal of the Boggs case before the Strasbourg court.

The spectators, who were seated on rows of benches behind the defendant's enclosure and also in a steep gallery, something like a surgeon's amphitheater, in the upper part of the wall opposite the jury, were taking advantage of the lull before the trial to size up the two barristers. Harman was a spry-looking elderly gentleman with sharp features, narrow lips, a wide smile, a clear gaze, large ears, and a tiny face. His wig fitted him perfectly: it might well have been fashioned out of his own hair. Moreover, it looked not the least bit anachronistic on him; on the contrary, he had a confident eighteenth-century presence that made everybody else in the room seem vaguely out of date. Robertson, by contrast, was clearly a modern man, a good deal younger than Harman, taller and fleshier, and with thick, almost bouffant hair, which would have stood any American presidential candidate in good stead, and atop which perched an absurdly cocked wisp of a wig. ("Geoffrey," Boggs asked him during one of the recesses, "how often do you have to take that thing to the vet?")

The den mother, or mother hen, of the court now rose and stamped her staff, instructing all present to rise for the judge's

entrance. A side door near the back opened, two dark-robed ushers entered and surveyed the scene, and then, presumably finding everything in order, bade their lord the judge, the Honorable Sir David McNeill, to enter. He did, and proved to be a kindly-looking, middle-aged, bespectacled gentleman, with dark bushy eyebrows. He was all decked out in a comfortable bright-red robe with white ermine sleeves, and, on his head, a distinctive white wig. In one hand he carried the traditional black cap, which he'd be required to don should he find it necessary, at any point in the coming proceedings, to sentence anyone to death for high treason. He walked to his bench, then turned to bow to the ushers, to the clerks, to the barristers, to us—I lost track of the bows. Courtroom novices, like me, tended to return all of them; the pros knew which single bow to respond to.

The judge now sat, and everyone else sat, and the judge called for the defendant Boggs to be brought up, and nothing happened. "Bring up the defendant," the judge repeated, and still nothing happened. The bailiff, flustered, went off to see what could have gone wrong and returned a few moments later to report that the officers downstairs had somehow misplaced their charge, the defendant Boggs, but were looking for him and would no doubt be delivering him shortly. All of us just sat around, politely nodding to each other. Finally, after about ten minutes, the hatch opened and Boggs was delivered to his fate. (Boggs subsequently told me he'd been frisked three separate times down there, in three successively deeper interior chambers, and had finally been remanded into a solitary cell. "That cell would have made a great studio," he reported. "A bright white cube. The walls were covered with scratched-in initials and insignias and slogans. I took out my pen and had just enough time to draw the beginnings of a pound note before they came to fetch me.")

— —

The judge announced that Boggs would no longer have to go through the ritual of pretrial incarceration, and then he sum-

moned a panel of prospective jurors. He told them that this was going to be a case involving the currency of the realm and asked if any of them had any ties to the Bank of England. One of them said that, actually, she was married to a man who worked for a company that did business with the Bank. What sort of business? Printing. The judge looked over at Robertson; Robertson smiled and shrugged—it didn't matter to him—and the woman was permitted to stay. Robertson made peremptory challenges of two other jurors, Harman accepted the whole lot, and, as quickly as that, we had our jury: eight women and four men, ranging in age from their early twenties into their sixties. They were a uniformly ordinary, middle-class-looking group, with the possible exception of one somewhat scruffy and disheveled gentleman in his mid-thirties.

The judge invited the prosecution to open its case. Harman informed the jury that this case was being brought under Section 18 of the 1981 Forgery and Counterfeiting Act, but the prosecution would be alleging neither counterfeiting nor forgery—only the act of reproduction, for which, he declared, there ought to be two simple possible tests: Does the copy suggest the original to a person looking at it, and was it obviously copied? If the copy met those tests, it would clearly be a reproduction, and therefore its creator would be in violation of Section 18—unless, that is, he had procured advance permission from the Bank of England, which, as part of its assigned protective role on behalf of the integrity of the national currency, had been granted unfettered discretion in granting or withholding such permission. The question was going to be a straightforward one: Had the defendant, Mr. Boggs, reproduced British notes or had he not?

The prosecution's first witness was a mid-level official with the Bank of England, Geoffrey Russell, to whom Harman successively presented the four Boggs drawings—of a ten-pound note, a five-pound note, and two one-pound notes—that formed the basis for the four counts with which the Bank was charging Boggs. Harman invited Mr. Russell to detail all the similarities between Boggs's drawings and standard pound notes of the same denominations. A strange tar-baby effect

developed here: each time Mr. Russell pulled an actual five- or ten-pound note out of his billfold to use in comparison, he had to surrender it as evidence. As a witness, he was being cleaned out.

Robertson, for his part, during the cross-examination, trotted Mr. Russell through all the obvious differences. At one point, when Mr. Russell commented that it had been some time since he'd studied the Boggs drawings, the last time he'd seen them having been before Christmas, Robertson said, "You mean last Christmas, the Christmas of 1986, when the Bank itself included reproductions of pound notes on its own Christmas cards?"

The judge scowled. "You're not suggesting, Mr. Robertson, that those reproductions were unauthorized?" he said.

"Oh, no," Robertson quickly assured His Lordship. "No doubt those reproductions were *easily* authorized." In subsequent asides, Robertson let it be known that the Bank of England had even granted permission to a chain of sex shops to reproduce a decidedly risqué version of a British pound note.

— —

At this point, the judge received word that the jury in the previous case had now reached its verdict, and he recessed our trial for lunch, so that the other trial could occupy the premises. Everyone got up and bowed, and most of our group left—all except me. I decided to stay on and witness the outcome of the other case. The trapdoor opened, and its defendant emerged to take Boggs's place. Barristers, solicitors, judge, and jury all trooped in, and there were bows all around. The jury announced its verdict on three counts of rape—not guilty—and was gratefully dismissed. The prosecutor then pointed out to the judge that there remained the matter of a fourth count, which had been held over for separate consideration. It appeared that at the moment of his arrest the defendant had been in possession of five counterfeit fifty-pound notes. The defense lawyer got up and explained that the defendant had been given the five notes earlier that evening *as a*

joke, and had kept them to show them around as such; he'd never intended to pass them. (This struck me as a novel defense, and I resolved to relay it to Boggs as a possible backup position.) The judge, however, was not amused. "A joke?" he said grimly. The defense lawyer immediately fell back on an alternative strategy, arguing that the seven months the defendant had already spent in jail, unable to post bail on the three counts on which he'd now been found not guilty, ought to be sufficient penance for this other offense. (Again this game of scales, I thought, of values weighed one against the other.) The judge considered that line of argument for a few moments, and, following a stern lecture to the defendant on the evils of counterfeiture, decided to accept it. End of that case, bows all around, and, a bit later, bows all around, resumption of ours.

— —

Harman's next witness was a somewhat more senior official of the Bank of England than Mr. Russell, Graham Kentfield, who turned out to be the boss of Gordon Edridge, the recalcitrant bureaucrat with whom Boggs had engaged in that unsatisfactory correspondence the year before, just prior to his arrest. (Edridge had meanwhile retired and was not being called as a witness; Mr. Kentfield explained that, in any case, the man had been acting under his direct orders the entire time.) Harman and Kentfield rehearsed the entire correspondence between Boggs and the Bank: Boggs's two letters asking permission, the Bank's two letters refusing it. Kentfield presented the aspect of a self-assured and unflappable bureaucrat: the validity of his position was self-evident, to him anyway, and its obvious validity to anyone else was equally self-evident. He explained that reproductions of currency notes made with even the most benign of motives—he cited the case of eye-catching advertisements in newspapers—could be used by a second party to diddle naive and trusting third parties (he told of instances in which reproductions of pound notes had been cut out of newspapers, hand-colored, and palmed off on unsuspecting little old ladies in Suffolk).

This was what the Bank had to protect against; this was why the Bank had a strict set of guidelines, which it sent to all prospective applicants, and which it had sent to Boggs. Boggs had been asking for "blanket permission" to contravene both the law and those guidelines—a request that, self-evidently, could only be met with a "blanket refusal."

In his cross-examination, Robertson tried to determine how this law and those guidelines could ever be made to apply to fine artists, as opposed to commercial artists. "Let me see if I have this right," he said to Kentfield. "If Mr. da Vinci was proposing to include some pound notes in his upcoming painting of *Christ Driving the Moneylenders from the Temple*, you're suggesting that, in keeping with the guidelines, he'd have to send the Bank a detailed sketch, in duplicate, taking care to leave the space intended for the bills blank pending your approval of the whole scheme? And, in keeping with your guidelines, were you to grant permission, he'd still be required upon completion of his project to destroy all materials associated with the image's manufacture? What does that mean? The brushes? The palette? The easel? The painting itself?"

Mr. Kentfield declared Robertson's example preposterous—for one thing, moneylenders in Christ's time would never have been lending British pound notes—and smugly asserted the self-evidence of common sense. Robertson tried to get Kentfield to admit that Section 18 clearly applied to mechanical, and not manual, reproduction; to commercial, and not fine, art; but Mr. Kentfield serenely stuck to his position. What Boggs had been doing was obviously reproduction; as such, it had required the Bank's permission, which Kentfield had not once but twice refused to grant: case closed, as far as he was concerned. Robertson got Kentfield to admit—and Kentfield saw no problem in this, either—that it was he alone who had decided not only how to reply to Boggs's initial request but how to reply to Boggs's appeal of that decision as well. Subsequently, in his summation, Robertson would describe Kentfield as a witness "whose brow doubt had never furrowed," and Kentfield, seated in the back of the courtroom at the time, seemed in no way bothered by that characterization.

Harman now called Inspector James Davies, the arresting officer from Scotland Yard, and reviewed with him the circumstances of Boggs's arrest and subsequent interrogation. Indeed, in a particularly surreal exchange, Harman had Davies assist him in reading the transcript of Boggs's entire post-arrest interrogation into the record, with Davies playing himself and Harman taking on the role of Boggs. ("Q: Did you draw or paint that article? A: It is my job to allow my thoughts and feelings to be expressed and communicated through visual work of my hands. For art to be true and just and honest, I must allow my inner self out. Q: Did you draw or paint it? I accept what you appear to be trying to indicate, but the question I am asking is not about why you might have done it, but if you did it. A: Can I claim total responsibility for all things which make me a human being, being that I consider this to be a part of or reflection of my self? I've gone into my mind to the place where art originates—and it is a very expansive place: I have yet to dent the territory, I am only beginning to explore it. Q: Did you with your hand with a pen, pencil or paintbrush—irrespective of the reasons, whatever they may have been, which caused you to do it—paint, draw or color this item? A: If you are asleep and you have a dream, are you responsible for the creation of that dream? I have bled onto this piece of work." And so forth.) Robertson, in his cross-examination, solicited from Inspector Davies the fact that Boggs had never been in trouble with the law before, and also Davies's own certain opinion that Boggs had never tried to pass off any of his drawings under false pretenses.

The judge adjourned the hearing for the day. Boggs, coming out of his enclosure, waved to Davies (who nodded nervously back) and then remarked to me that he'd become good friends with the inspector in the months since his arrest. On each occasion he'd encountered Davies during the various pretrial procedures, Boggs said he had regaled the inspector with details of his most recent exploits and shown him his most recent drawings. "Don't do that," Davies had pleaded. "Don't tell me that. Don't show me that. I don't even want to know about any of this."

Now, however, Boggs seemed somewhat rattled by his day. "It's strange to be sitting up there listening to all these people talking about you and your work, and not be able to say a word," he observed. He was too restless to go home, so I suggested he might like to take in a play. We looked through the paper and naturally settled on Caryl Churchill's *Serious Money*. Churchill had described her play as "a City Comedy," and, dealing with the world of speculative high finance in the wake of London's "Big Bang" deregulation of financial markets (and before the Bust), it presented a class of people who were in the regular habit of producing wealth out of nothing in a manner considerably grander than anything Boggs had ever envisioned.

— —

Back at the Old Bailey the next morning, the bailiff came up to Boggs in the anteroom and inquired about some sketching he'd seen him doing in his notebook during the previous day's testimony. "You weren't sketching the judge or any of the witnesses, were you?" he asked.

Boggs said no, he'd been sketching the sword and the coat of arms on the wall above the judge.

"Well, that's strictly forbidden," the bailiff informed him sternly. "It's forbidden for anyone to sketch any of the persons or things inside the courtroom during a trial, and I will not have such behavior in my courtroom." (That prohibition, by the way, accounted for another curious spectacle I'd come upon while walking around the Old Bailey during breaks: courtroom sketch artists who kept barreling out of their courtrooms into the hallway and frantically sketching from memory as much as they could recover before diving back for another visual draught.) Boggs promised to desist from such insolence, and reported to his seat.

Once the proceedings had resumed, Harman rather quickly wrapped up his presentation of the prosecution's case. He, too, seemed to feel that the evidence of reproduction was self-evident. Robertson now asked the judge if he could make

certain technical submissions on why the case should be dropped without further ado, and the judge, though he looked dubious, excused the jury until after lunch.

Robertson's submissions had to do with the misapplication of the legal term "reproduction" in this case, and they were technically dazzling—at times too clever by half (as when, to buttress his claim that "reproduction" had to be total and exact and without any variation whatsoever, he cited phrases in parliamentary acts which asserted that a given section should be understood to "reproduce" such-and-such a section from another act, by which was obviously meant "taken in toto verbatim," and not "sketched out to an approximate likeness"). Finally, however, they proved futile.

The judge seemed to feel he was dealing with a common-sense application of a word in common usage, and he really couldn't see what all the fuss was about. "So I reject your submission, Mr. Robertson," he concluded at length, "though I thank you for making it. It was most interesting."

Robertson didn't seem deeply disappointed: perhaps he'd simply been rehearsing for Strasbourg. Boggs, for his part, had spent his morning in the dock sketching merrily away.

After lunch, the jury came back, and Robertson launched his case with a flamboyant opening statement. In contrast to Harman's cool, crisp, efficiently friendly style, Robertson's was rhetorically expansive. "The *Mona Lisa* is not a reproduction of an Italian woman," he told the jurors, "and van Gogh did not reproduce sunflowers. To be sure, Boggs is not an artist of that caliber—and being an artist would in any case be no defense in itself—but if you just look at his drawings you will see that they are not reproductions but, rather, artists' impressions, objects of contemplation." He went on to claim that not only had these drawings never been passed off as real currency but they couldn't possibly be. He had repeated recourse to what was apparently a quasi-legal standard, that of the "moron in a hurry," as in "Not even a moron in a hurry would mistake these drawings for the real thing—they are obviously drawings." (There was in subsequent examinations

and cross-examinations much discussion of the relative capac-
ities of Boggs's drawings and hurried morons to fool and be
fooled. What about, for instance, a moron in a hurry *in a
dimly lit room*?) "No," Robertson concluded, theatrically,
"Boggs's drawings and real money are as different as chalk
and cheese, or rather as chalk and cheese that's been carved
out to resemble chalk. Boggs is no mere reproducer, he's an
artist. You may or may not like what he does; you may find
what he does of value, or you may feel a Boggs isn't worth the
paper it's drawn on. The invitation to come up and see my
Boggs sometime may hold no fascination whatsoever for you.
But that's not the point. The point is that these are original
works of art and not reproductions at all."

With that, Robertson called his first witness, Boggs himself.
Under friendly questioning, Boggs reviewed his background
for the jury, describing how he'd come to his current preoccu-
pations, how he drew his drawings and "spent" them, what be-
came of them after they were spent, how his true fascination
was with the very act of transaction itself, how he'd first heard
about his potential legal problems with the Bank and had im-
mediately taken steps to address them, the stone wall he'd en-
countered there, and so forth. He was at his most charming.

During the cross-examination, however, Harman clearly
rattled him. Following a come-on-you're-an-intelligent-young-
man sort of prologue, he showed that Boggs himself had de-
veloped doubts about the legality of his production (he re-
turned again and again to the evidence of the two letters), and
that when he failed to get the reassurance he'd desired, he had
simply resolved to ignore the prohibition and break the law.

Boggs insisted that the law couldn't possibly apply to his
work.

Harman interrupted him abruptly: "Are you suggesting
that because your drawings are works of art, they are inca-
pable of being reproductions?"

"I suppose so," came Boggs's carefully measured reply,
"because once you crossed over the line into reproduction, it
would no longer be a work of art."

Harman was clearly trying to leave the jurors with the impression that Boggs considered himself, as an artist, to exist in a universe beyond the reach of laws that applied to mere mortals like them. But the jurors, uniformly poker-faced throughout the proceedings, were giving no indication of whether they accepted that characterization. (In one surprising development, the slovenly juror of the previous day appeared to have cleaned up his act considerably: he was dressed in a casual suit, and had brought along, as leisure reading, a history of merchant banking.)

— —

The third day of the trial began with Boggs still on the witness stand (he had by now attracted a bevy of beautiful young women who gazed down upon his ongoing martyrdom in attitudes of dreamy concern from perches in the spectator gallery), but he was soon replaced by three expert witnesses. Robertson had planned to call that editor of the *Oxford English Dictionary* to testify concerning the meaning of "reproduce," but he had now decided not to (in fact, now that the defense team reexamined the book, it turned out that one of the *OED*'s ten definitions of the word came uncomfortably close to describing precisely the sort of activity Boggs was engaged in). Instead, Robertson called René Gimpel, a prominent art dealer; Michael Compton, a distinguished senior curator of the Tate Gallery, recently retired; and Sandy Nairne, the director of visual arts at the Arts Council of Great Britain. All three testified that to call Boggs's drawings "reproductions" was to utterly confound the word's universally accepted art-world meaning. They rehearsed all the differences between Boggs's drawings and real bills, including, in one interesting line of questioning, that of value itself: they confirmed that Boggs's drawings regularly fetched prices in excess of one hundred times the face value of their models. To which Robertson extrapolated: "Has anyone here ever heard of a reproduction being worth *more* than its original? How, then,

can Boggs's drawings be considered reproductions?" He went on to note, in passing, that it would be preposterous for someone to pass off a Boggs drawing to some unsuspecting third party at merely its face value—and that anyway this had never happened in the more than seven hundred instances when his drawings had changed hands—so that that concern of the Bank's was likewise unfounded.

Compton spoke of the different traditions that the two sorts of objects addressed: the banknotes merely addressed the tradition of earlier banknotes, whereas Boggs's drawings manifestly alluded to such earlier-established art-world traditions as trompe-l'oeil, barter art, Pop art, and conceptual/performance art. "Excuse me," interrupted the judge, who seemed to relish playing the role of the jovially dense common man. "How's that? *Con*ceptual-slash-performance art? Do I have that right? Oh dear." (At moments like this, the judge's dark eyebrows would dance behind his thick-rimmed glasses in a virtuoso performance of their own, reminiscent of the highest traditions as practiced by such masters as Senator Sam Ervin.) "The banknote is intended to exude anonymity and authority," Compton resumed. "Boggs's drawings instantly and overwhelmingly exude individuality."

With each of these witnesses, Harman seemed content to get the man to admit on cross-examination that, darn it, for all their supposed differences, there were still plenty of similarities between the Boggs drawings and the actual bills, and, in fact, the Boggses were obviously drawings of standard bills. It was like pulling teeth.

With that, the presentation of evidence was over. Harman completed his summary to the jury, and Robertson started his before lunch and concluded soon after. At that stage of the proceedings, it seemed to some of us in the press box that it was going to come down to a question of whom the jury resented being condescended to by more —distant, arbitrary bureaucrats who saw their authority as beyond appeal, or eccentric, self-assured art types who imagined their precious categories to exist outside the law. Such, at any rate, were the

caricatures that Robertson and Harman chose to emphasize in their closing statements.

— —

The judge now gathered his papers together and began his summation of the case and his directions to the jury. For three hours, in a presentation that carried over to the next morning, he expertly analyzed the relevant laws and reviewed the various lines of argument and presentations of evidence. His tone was friendly, congenial, but finally no-nonsense. He was particularly succinct in his summary of the case for the defense, enumerating each defense argument in turn and affably declaring each, in turn, to be utterly without merit. After reviewing the basic provisions of Section 18, he said, for example, "The fact that a drawing might not resemble a currency note in every particular cannot provide a defense against this charge. The fact that the maker did not intend it to be passed, or that it might not even be capable of being passed, would not provide a defense, either. Nor would it be a defense to claim that the copy was made by hand rather than by machine: the parliamentary act makes no reference to mechanical means, and you can't go putting into an act of Parliament words which Parliament itself did not put into the act. Nor would the assertion that the copy in question were a work of art constitute

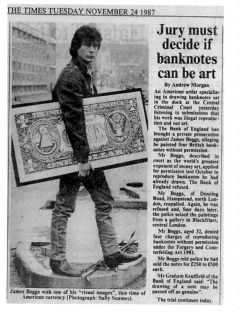

THE TIMES TUESDAY NOVEMBER 24 1987

Jury must decide if banknotes can be art

By Andrew Morgan

An American artist specializing in drawing banknotes sat in the dock at the Central Criminal Court yesterday listening to submissions that his work was illegal reproduction and not art.

The Bank of England has brought a private prosecution against James Boggs, alleging he painted four British banknotes without permission.

Mr Boggs, described in court as the world's greatest exponent of money art, applied for permission last October to reproduce banknotes he had already drawn. The Bank of England refused.

Mr Boggs, of Denning Road, Hampstead, north London, reapplied. Again, he was refused and, four days later, the police seized the paintings from a gallery in Blackfriars, central London.

Mr Boggs, aged 32, denied four charges of reproducing banknotes without permission under the Forgery and Counterfeiting Act 1981.

Mr Boggs told police he had sold the notes for £250 to £500 each.

Mr Graham Kentfield of the Bank of England said: "The drawing of a note may be passed off as genuine."

The trial continues today.

James Boggs with one of his "visual images", this time of American currency (Photograph: Sally Soames).

Headline from the British press

any sort of defense whatsoever." He paused to smile warmly at the jury, and resumed, "This case is not about artistic freedom or freedom of expression or anything of the sort. You may have heard it described as a test case; nothing could be further from the truth: this is a very narrow and specific case. Please don't be deluded into imagining that you're trying the contemporary art establishment." Even veteran British trial reporters, who had seen a lot of biased summations by judges in their time, were taken aback by the tenor of this presentation. "This is the world's most genial hanging judge," one reporter scrawled in a note he passed to another.

"It provides no defense whatsoever that the drawings in question may be worth more than the originals," the judge continued, "or, for that matter, that they may in some manner provide the defendant with a principal source of his livelihood. Whether or not the defendant understood the law is immaterial. The comparative quality of the material upon which the copy was executed can be of no relevance. Evidence of the defendant's good character is likewise beside the point: that he were a man of evidently good prior character could in no way help us to determine whether he had in fact committed this specific crime, just as the reverse would be true. You would be untrue to your oath if you took mitigating circumstances into account in finding the defendant not guilty. I will of course take those circumstances into account in determining sentencing." The judge now paused significantly. "Or lack thereof"—he smiled—"should that prove necessary."

The first reporter's note now came back to him, over-scrawled, "Or the world's most fiendish tweaking one?"

The judge seemed to be directing his jury the way Captain Hook directed his prisoners down the plank. It was pretty clear what he was expecting from all the parties involved. The jury would be a good jury and return a guilty verdict, he would be a good judge and impose a suspended sentence, and we could all get out of here and have a good weekend.

"Really, ladies and gentlemen of the jury," the judge went on, "we have a pretty straightforward question here. The word 'reproduction' is a perfectly common one used in every-

day discourse; we all know what it means. And we can all also recognize that Section 18 forbids not just the reproduction of entire bills but even any 'reproduction in part.' If there is no more than just the reproduction of an actual serial number, you may find it difficult not to find that 'reproduction in part' has taken place.

A chill went through the press ranks: we flipped back through our notebooks and recognized in horror all the times we ourselves had transcribed the various serial numbers as they were being entered in evidence. Again, the judge smiled cordially. "But that will be for you to decide, not me."

By the end of the judge's summation, it was beginning to seem that the jury's decision might turn not just on the question of its respective antipathies toward art types and bank bureaucrats but also on the extent to which its members might, on the one hand, have grown to resent the rigidities of this utterly charming and avuncular judge and developed a willingness to rebel or, on the other, might have been rendered irredeemably crazy by precisely those congenial rigidities and hence without wills of their own.

Shortly after eleven-thirty on the morning of the fourth day—Thanksgiving Day back in America, as it happened—the judge concluded his summation and direction, the jury headed for its chamber, and Boggs and the defense team repaired upstairs to the court cafeteria to wait out the jury's deliberations.

— —

Robertson and Stephens were pretty grim: the judge's instructions had been devastating. Robertson was already sketching out his strategy for Strasbourg. Stephens asked Compton, the Tate's man, whether, in the event of a guilty verdict, the defense might at least move to wrest Boggs's confiscated works from the presumably destructive hands of the Bank, so that they could be reserved under the aegis of the Tate's Archive. Compton said that while such an arrangement would proba-

bly be acceptable it was important to understand that there was a distinct bifurcation between the Tate's Archive and the Tate's Collection—that just because works might be accepted into the Archive did not mean that they had been deemed worthy of being included in the Collection. "Now," he went on, musingly, "that does not mean that at some future date a work in the Archive might not be raised up into the Collection." He paused for a moment, his face darkening. "Or, I suppose, things might just as well go the other way around."

Word suddenly arrived that everyone was to return to the courtroom immediately: the jury had reached its verdict. It had been out only ten minutes. Stephens and other members of the defense team walked close to Boggs on the way downstairs, urging him to keep his cool, acknowledging that though the sudden verdict looked very bad, they would immediately launch their appeals on any guilty verdict, even one with a suspended sentence, and that the important thing was that he stay calm and collected, and not complicate matters by shooting his mouth off and incurring a contempt citation. Boggs, taking it all in as he descended the stairs, seemed pale and short of breath.

We all poured into the courtroom (there seemed to be a lot more press people about than at any time earlier), the judge's entry was announced, we all rose, he entered, we all bowed, we all sat, the jury was summoned and filed in, they all sat. The clerk asked the jurors whether they had selected a foreman. Indeed they had: the formerly scruffy gentleman now rose as their spokesman, decked out in the immaculate three-piece suit of an established banker. The judge inquired whether the jurors had arrived at a verdict. Yes, they had. Was it unanimous? Yes, it was. And what was it?

Not guilty on all four counts.

The judge rolled his eyes momentarily skyward and then smiled. Harman did likewise. Now, the judge and Harman smiled bemusedly *at each other*. Robertson initially seemed almost taken aback (the man had virtually reserved his suite at the Strasbourg Hilton), but then broke into a wide grin.

Stephens was beaming. Boggs threw his arms up in the air in unmitigated exultation.

The jury had turned the judge's plank into a springboard from which it had propelled itself clear out of the law's strictures.

"Well," the judge said. "We've certainly all learned something here today." He thanked the jurors and dismissed them, declared Boggs a free man, ordered his confiscated drawings returned to him, and adjourned the proceedings.

The first person to shake Boggs's hand as he emerged from the defendant's dock was Inspector Davies. Boggs went over to the evidence table, pulled out his once-confiscated drawing of a five-pound note, and handed it to Stephens as a bonus.

A few minutes later, on the sidewalk outside the Old Bailey, as Boggs was being interviewed by London Weekend Television, he was spotted by the jurors filing out from their separate exit. They all rushed over to hug and congratulate him.

"It was the correct verdict," one of the jurors solemnly told the television reporter.

"We *loved* the work," the man in the three-piece suit assured Boggs confidentially.

Boggs now turned to the camera and announced that in celebration of the verdict he would embark immediately on a new project. From that moment on, he said, for the next year, he would spend no real money whatsoever. "I will live off what I can procure with my art," he declared. "My needs are limited. If I can't get something with a drawing, I'll just make do without it. It's going to take an awful lot of work and an awful lot of scrambling, but I want to see if it can be done.

"Anyway," he said, "I've got a head start." He reached into his satchel, pulled out his sketch pad, and displayed a drawing of a fifty-pound note, which, he explained, he'd been laboring over up there in the dock, the entire last half of the trial.

Justice atop the Old Bailey, London,
sword in one hand, scales in the other

A Boggs Fun Buck

LIFE SIZE &

<div align="center">❦</div>

AFTERWORD

I. Zeno's Jester (1993)

IT PROVED the hardest thing he'd ever done, that busi-
ness of living an entire year without recourse to actual
money of any sort, subsisting exclusively on what he could
scare up by way of his art. "It gives you a very different per-
spective when the lack of money is self-imposed rather than
super-imposed," Boggs recalled for me some years later, "a bit
like those artists who work in negative space, drawing every-
thing else, that is, except the thing they're drawing: attaining

comprehension through elimination. And things really did get strange: I stank a lot that year, unable to make use of laundromats. Got lots of parking tickets. Not being able to use pay phones got to be just a huge hassle. I had many hungry nights and all sorts of close calls."

His poverty was all the more discomfiting in light of his growing fame, and the notoriety was itself a source of continual aggravation. Only three days after his triumphant verdict, Boggs returned to his flat late one evening to discover it ransacked, with most of his currency drawings stolen. In all likelihood, the vandals had been reading about "the defendant, of 15 Denning Road, Hampstead," in the British tabloids throughout the previous week, and about his strange drawings, "in many cases worth well over one hundred times their face value on the current art market." Boggs nevertheless had some difficulty convincing the neighborhood constables, who arrived to take his report of the incident, that these simple drawings were in fact worth more that the mere, say, five pounds that they appeared to represent. Though there were no further such break-ins, Boggs did grow increasingly weary of scavengers regularly rummaging through his garbage for aborted drawings; and by the end of his moneyless year, he'd had enough of England and resolved to return to America.

His girlfriend at the time, noting the exhaustion brought on by the year of moneyless scrambling and the subsequent months of arduous transplantation, convinced him it was time to take a real vacation, one, that is, free of money-drawing of any sort. They booked a flight to Australia, but as Boggs says, "The flight was *reaaallllly* long, and what was I supposed to do? We'd picked up some Australian dollars from the bank the day before, I'd never seen them before. . . . How could I have been expected to resist?" One of his fellow passengers took note of Boggs's developing sketch, the two got to talking, the fellow started raving about the best hotel in Sydney, the Sebel Town House overlooking Elizabeth Bay, and effectively dared Boggs to see if its principals could be inveigled into accepting a drawing. Boggs's girlfriend was not amused, but, as he says, how was he supposed to resist such a direct

challenge? He assured her that in all likelihood, he'd show his bill, the people there would show them the door, and that would be that: he promised he wouldn't perpetrate a single other drawing the entire rest of their trip. When they got to the hotel, the manager was called over, he examined the drawing, dickered over a few details, and weighed things in his mind a moment before—ding!—ringing the desk bell and motioning for two bellhops to escort these valued new guests to their suite. "The room was excellent," as Boggs recalls.

They were there for a week, the inevitable newspaper article appeared on Day Six, and the next morning, just as they were getting set to leave, a crack team from the Australian Federal Currency Squad barged into their room, cuffed the notorious blackguard, and hauled him off to jail. "That room, by contrast," Boggs recalls, "was not excellent in any way." Boggs eventually made bail but was forced to endure three and a half weeks of house arrest back in the Sebel Town House ("Not bad, not bad at all") before being extended a slightly longer judicial leash. (Boggs's initial lawyer on the case proved to be Geoffrey Robertson's brother.) Four months later the trial began, though not far into the proceedings, the judge exploded, throwing the state's entire case out the window and awarding the defendant $20,000 for his troubles.

Boggs returned to America and a burgeoning career. He landed a major show with a high-flying New York dealer, Vrej Baghoomian (who'd recently taken to showing Jean-Michel Basquiat as well), and soon thereafter secured a one-man touring exhibition, entitled "Smart Money/Hard Currency," organized under the auspices of the Tampa Museum of Art. But, just a few weeks before the opening of that show, in October 1990, Boggs experienced his first serious brush with the American Secret Service, who apparently turned out to be somewhat lacking in the bigger-fish-to-fry dimension after all, for its agents now moved to quash publication of the show's catalog as it was then conceived, with actual-size, full-color reproductions of Boggs's drawings. (The catalog's printer, threatened with bankruptcy or worse, caved completely, and in the end, the images in the catalog had to be blown up to

150% scale, though this manifest violation of the artist's intent was protested in a notice on the catalog's contents page.)

The show's second stop, at the Art Gallery of Carnegie Mellon University in Pittsburgh, led to Boggs's improbable long-term appointment as the Fellow for Art and Ethics at that school's Center for the Advancement of Applied Ethics, and the transplantation of his main operations to that city.

Some months later, while Boggs was ensconced in a hotel near the site of the "Smart Money" show's final venue, in Cheyenne, Wyoming, there came another loud knocking at his door. A furiously brusque Secret Service agent came barging in, with the local U.S. Attorney in tow, and the two started on a rampage, threatening to confiscate everything in sight. Once Boggs was able to ascertain that they didn't have a search warrant, he talked them into taking only fifteen sample drawings—one of each type he was currently circulating—for dispatch back to headquarters in Washington where a final determination could be made as to their legality. His proffer of the fifteen drawings was conditioned on the U.S. attorney's explicit promise that the bills would be returned to him unharmed immediately following such determination. As the months passed, this particular U.S. attorney decided to pass on prosecuting Boggs (declaring, unusually sensibly, that he himself didn't care to participate in "the Boggs publicity game"), but the Secret Service, those promises notwithstanding, declined to return any of Boggs's fifteen bills—in fact, they wouldn't even tell Boggs where they were. Over the next year, astride a motorcycle he'd been able to procure through an especially elegant transaction, Boggs embarked on a quixotic, typically forlorn, quest—back and forth, Pittsburgh to Washington—to track down and retrieve those drawings (a quest which in turn formed the narrative backdrop for a notable documentary film, *Money Man*, produced for the BBC.) Each of these run-ins with the law, however, only further emboldened Boggs, provoking him into making ever more daring forays into the borderland between artistic self-expression and legal constraint. Or so I gradually came to realize during

those months, whenever Boggs would drop by for one of his occasional visits to New York, bringing me up to date.

In many ways, the five years since his London trial had been immensely successful ones for Boggs—the shows, the traveling museum exhibit, the Carnegie Mellon fellowship, over $250,000 in successfully "spent" transactions to date. And yet, to hear him tell it, they'd also been years of endless churning. "Believe me, I've tried to kick this habit," he commented one day. "I'll resolutely start out on some new tangent—a series of abstract canvases, for example—but then somebody always comes along and asks something like 'Well, what do you think that painting's worth?' and I find myself being drawn right back in. Because what does anybody mean by 'worth'? And how's that different from 'value'? And what precisely is it that we value in value? What is giving good value, or getting it? And before I know it I'm right back in that hall of mirrors, with the mirrored door clicking shut behind me."

Short of escaping the hall altogether, Boggs, it seemed, had been endeavoring to give each new foray a clean, fresh edge—an edge that invariably brought him closer to The Edge. Thus, having begun by trading hand-drawn renditions of bills, he took to wondering, Why not attempt to traffic in multiples of various sorts, initially in lithographs (would people accept those?) and then in crude engravings (would those get him in trouble?) and finally in simple photocopies? People did keep accepting them—by no means everyone, but enough people to keep things interesting—and treasury police all over the world grew more and more concerned.

For a long time I had thought of Boggs as a Socratic artist —money's gadfly—endlessly confounding his everyday interlocutors with the precariousness of everything they took for granted about money and art. (Why accept one kind of drawing and not another? Why, exactly?) But, listening to him on some of his visits around that time, I began to realize that his was more of a Zenonian passion. Zeno of Elea was the pre-Socratic philosopher who contrived a famous series of para-

doxes around the notion of infinite regress—the idea, for example, that a runner in a race must first traverse half of the course, and then half of the remainder, and then half of the remaining remainder, such that he could never actually reach the finish line. Boggs seemed to be engaged in an analogous brinksmanship with the laws of counterfeiture, converging ever more closely upon a limit he might, depending on one's point of view, never actually attain. (This insight reminded me, in turn, of the old story about the mathematician and the engineer who were embroiled one afternoon in a dispute about Zeno's paradox when a beautiful woman happened to walk by. The mathematician, the paradox fixed in his mind, despaired of ever being able to attain her, but the engineer remained serenely confident that he could get close enough for all practical purposes. "Close enough for all practical purposes" is a territory that both Boggs and the Secret Service seem to spend a lot of time thinking about.)

— —

As the latest installment in his Zenonian passion, Boggs informed me one afternoon toward the end of 1992, he'd decided to raise the ante considerably. He was about to embark on what he was calling "Project Pittsburgh." He had fashioned an entirely new edition of Boggs bills—brand-new drawings in denominations ranging from one, five, ten, and twenty dollars on up through ten thousand. He'd laser-printed a million dollars "worth" of these bills—enough to fill a bulging suitcase. Starting on January 1, 1993 ("I like to keep these things neat, everything in a single calendar year," he explained), he was going to try to spend these bills in his usual fashion, by getting people to accept them knowingly in exchange for goods and services; only this time he'd be adding a new twist: he was going to encourage anyone who accepted his bills to keep them in circulation. This time, he was using the back side of the bills as well: an elaborate lacework design filigreed around five empty circles. Anyone accepting a bill was to immediately press his or her thumbprint into one of

the empty circles ("just like being arrested," Boggs noted, with evident satisfaction), and the bill would not be deemed to have completed its life cycle until it had changed hands five times, acquiring a full complement of thumbprints. "I want others to share in the fascinating experience of trying to get people to accept art at face value," Boggs said, with expansive generosity. "And I, in turn, want to share in my collectors' experiences of trying to track these pieces down." Be that as it may, the practical consequence of Boggs's experiment was that he was going to be creating five million dollars of value out of nothing—an alchemical transformation likely to provoke the Internal Revenue Service every bit as much as the Secret Service. (Boggs assured me that he stood ready as always to cut the IRS its own fair share of Boggs notes.)

And sure enough, the Secret Service had lately begun showing signs of increased agitation. Back in October, when Boggs had paid a courtesy call on the local Pittsburgh Secret Service offices (he always tries to keep the local constabularies apprised of his plans, precisely so there can be no subsequent imputation of chicanery), they confiscated copies of his "Smart Money" catalog as well as a book of mine which included an earlier version of this very essay—he'd brought them along as evidence of his art-world bona fides—summarily declaring the books themselves contraband. And then, on the morning of December 2, a few days after a detailed exposition of his plans ran in a Pittsburgh alternative newspaper, Boggs looked up from the dashboard of his beat-up Nissan pickup to find himself surrounded by flashing lights and officers waving badges. "Four Secret Service agents," he subsequently told me, "two Pittsburgh police, three search warrants—one for my person, one for my home and studio, and one for my Carnegie Mellon office." The agents escorted Boggs back to his apartment, and proceeded to search. "They just tossed the place like so much salad," Boggs recalls. "They emptied the file cabinets, scattered the contents all over the floor, upended drawers, accidentally intentionally broke my glasses—dropped them on the floor and then ostentatiously stepped on them. They were confiscating drawings left and

right, and receipts, too—seven years' worth of work." They zeroed in on the three remaining British pound note drawings, the ones the London jury had ordered returned to Boggs after that trial, and confiscated those; they cornered the seven early U.S.-dollar drawings that Scotland Yard had originally confiscated as part of its investigation, the ones which the Secret Service at the time, declining to join in the prosecution, had itself ordered returned to Boggs—and, evidently now changing their minds, they confiscated those, too. "I have a file detailing the appearances of money in ads and other sorts of media—they took that. I asked, What do you need that for? 'Evidence of intent.' I said, What do you want the receipts for? They're of no use to you and to me they're irreplaceable. 'Evidence of transactions.' It was incredibly humiliating—there was this terrible, all-permeating feeling of violation." Boggs was shaking as he told me this and seemed genuinely upset. "They left the place a shambles. It'll take me months to even figure out everything they took—let alone locate anything they left behind."

Afterward, the raiding party moved on to his Carnegie Mellon office and joined up with a half dozen other agents already on the scene. "'Where are you hiding the million dollars?' they kept demanding," Boggs reported. "And, of course, I wouldn't tell them. 'You're in big trouble, buddy. Manufacturing counterfeits. Uttering counterfeits.' Uttering—that means passing them, spending them. 'You're looking at fifteen years and a five-thousand-dollar fine on each count. And you stand a good chance of getting the maximum, because you've been duly warned. Now, where's the million dollars?' I told them they knew they didn't have a case or else they'd arrest me right then and there. 'Arrest me or leave me alone,' I said. And, as for the million, they could come to a public performance, which had already been announced for that Saturday, in which I'd be participating with several other Pittsburgh artists and where I'd be displaying the work for the first time. They'd be able to see it like everybody else."

The Secret Service didn't arrest Boggs that afternoon at Carnegie Mellon, though they did confiscate further batches

of evidence. Nor did they arrest him that Saturday night, when, before more than four hundred art fans ("The place was pulsing, like a heart"), he indeed displayed his bulging briefcase containing the million in Boggs bills. He taunted the agents he recognized in the audience, saying, "Here it is. Go ahead, arrest me. Okay, you're self-conscious. I'll wait for you outside." He did. Nobody came by.

It wasn't entirely clear what the Secret Service and the United States Attorney for the Pittsburgh District were up to in this latest skirmish with Boggs. The signals they were sending forth were decidedly mixed; neither office was willing to comment to the press beyond characterizing their efforts as an ongoing investigation into possible violations of Section 474, among others, of Title 18 of the Federal Criminal Code and Rules, the one which expressly forbids making "obligations" in the "similitude" of any United States currency. On the one hand, it seemed, they might be gearing up for a major trial, figuring that Boggs had finally gone too far, and that finally they stood a good chance of convincing a jury that they were simply trying to protect some future innocent shopkeeper, someone not unlike themselves, from unwittingly getting saddled with bum paper. After all, they might have been intending to argue, even if Boggs himself was going to be scrupulous in abiding by his rules of transparent disclosure, who could predict the character of the third or fourth transaction down the line?

Or, on the other hand, they might instead have now embarked upon a preemptive war of attrition. "What's it going to take, Boggs, to make you stop?" Boggs claimed that one of the agents kept yelling at him during their December run-in. "Are we going to have to come by and do this to you every other week?" If that was their plan, they might have been daring him to sue them to get them to stop, both sides knowing that in such a suit his odds would be decidedly narrower: he would be the plaintiff and they the defendants; in all likelihood, they'd be able to confine the case before a judge without a jury; all they'd have to prove would be that they had probable cause to engage in the ongoing investigation of

which these confiscations were a necessary part. In any event, the entire ordeal could well end up costing Boggs a fortune in real money he didn't remotely have.

"What's driving them so crazy?" Boggs asked me for-lornly—and somewhat rhetorically—one day around this time. "I mean, it can't just be the alleged counterfeiting. A million dollars, even five million—that's less than nothing in the money stream. No, it can't be just that. It must be the way these bills of mine subvert the whole system, calling into question the very credibility of the country's entire currency. Because what is it all based on?" He was warming once again to his main theme. "Nothing. Sheer faith." He reached into his satchel and pulled out one of his Pittsburgh bills. "Look here." He showed me the back side with its five empty circles, each awaiting its thumbprint. "I based that on this bill here." He pulled out a photocopy of that 1886 five-dollar silver cer-tificate. "In the old days, as you know, paper was sheer mystifi-

J. S. G. Boggs, *Project: Pittsburgh* (1993). Back of a Boggs bill with five ovals awaiting successive thumbprints.

cation: nobody trusted it. So that, as in this case here, they literally portrayed the five silver dollar coins for which you could redeem the paper on the bill itself. And you used to be able to do precisely that—to cash in the paper for specie. Not anymore, of course. There's a great old cartoon by Thomas Nast

Back of a U.S. five-dollar greenback note (1886), depicting the five silver dollars for which it could be redeemed at any time

from around that same time which shows a gold coin standing on its side, with an arrow pointing to it saying 'This is specie'; and the coin is casting a faint shadow, with an arrow pointing to it saying 'And this is paper money.' Now that paper has even lost its gold backing, it has become the shadow of a shadow."

Another Zenonian regress—Boggs's art

Thomas Nast, *A Shadow Is Not a Substance* (1876)

turned out to be mirroring, from its own side, the infinite regress of value inherent in paper money itself.

Boggs flipped the bill over, revealing a near-perfect rendition of the back of an ordinary ten-dollar bill, with its magis-

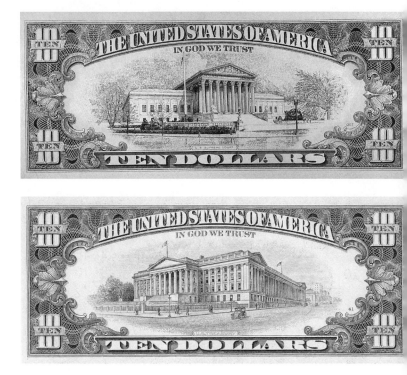

TOP: J. S. G. Boggs, *Project: Pittsburgh* (1993). Back of a ten-dollar bill.

BOTTOM: Back of an actual U.S. ten-dollar bill

terial representation of the U.S. Supreme Court Building. "Terrific likeness," I said.

"Think so?" Boggs smiled.

He reached into his wallet and extracted a real ten-dollar bill, on the back of which was a representation of the U.S. Treasury Building.

Nice trick. I asked him which denomination the Supreme Court actually graced, and he answered, "None. I made it up. It's my own fantasy."

Maybe, it subsequently occurred to me, he'd put the Supreme Court there in anticipation of that perhaps not so distant day when the full panoply of Boggsian perplexes would be landing squarely at its steps.

In the meantime, Boggs had returned to Pittsburgh and started spending his new bills. On January 1, he passed six prints, "worth" a total of twelve hundred and thirty dollars. One of them, a crisp Supreme Court ten—clearly a bill in a hurry—had already changed hands three times within the first week.

II. Mad Hatter (1998)

Or maybe not in that big a hurry after all. Five years on and the legal ramifications of that Pittsburgh raid were still shimmying their way up and down the American judicial system, with the Supreme Court itself apparently still a few rungs off . . .

Or so I was given to understand when I caught up with Boggs again the other day, this time in a coffee shop in Manhattan's midtown garment district. As it happened, he was wrapping up a preliminary negotiating session with Donald Sussis, a jovial, fastidiously white-bearded furrier—or rather, apparently, a soon-to-be an ex-furrier (it wasn't quite clear). Sussis and Boggs had been feeling each other out regarding the possible purchase, for drawings, of either a mink or a silver-fox coat, and Sussis seemed singularly open both to the possibility itself and, indeed, to its historical inevitability. "Of course, beaver pelts," he pointed out, "were the currency of choice around these parts not that many centuries ago. Beaver and fox and deer . . . Why do you think they used to call dollars 'bucks'? People carried around a brace of pelts and exchanged them for goods, like money. Or else, in effect, they had their walking-around-money fashioned into hats or clothes. Furriers were the bankers of first resort, though they

also developed a reputation for being a bit daft—hatters especially, what with the effects of inhaling all the cyanide fumes involved in the pelt-curing process. Hence that old cliché, 'mad as a hatter.'"

Boggs pointed out how in some countries they still included drawings of minks and otters, for example, on the bills themselves—as a sort of throwback to that era. He had included such a bill—a recent note from the post-Soviet state of Lithuania featuring two minks playfully cavorting—in an installation on the history of money which he'd recently curated for the lobby of the main midtown office of Andersen Consulting. "Sure," Sussis concurred, "and until recently even American dollar notes featured furs. Take a look at Benjamin Franklin's collar on the old $100 bill—though you'll also notice how on the new $100's, the times being what they are, that fur has been conspicuously removed."

Ah, yes, the times being what they are. Indeed, Boggs con-

Recent Lithuanian banknote

fessed that he had been running up against surprisingly intense opposition, from among his friends, to his even entertaining the notion of a transaction involving furs. "In fact," he marveled, "the sheer intensity of the reaction is beyond al-

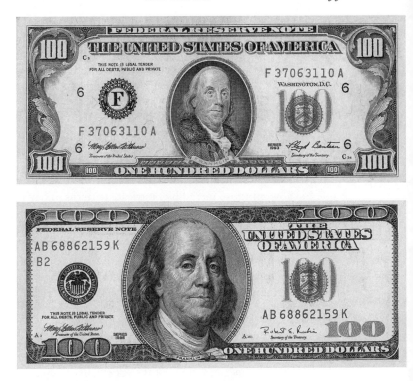

most anything else I've ever encountered. Fur these days seems to make people even crazier than money-drawing does, and that's really saying something. Frankly, it's given me pause."

Boggs had been trying to figure out some way to square this particular circle—to achieve a fur transaction (both for its own sake and for the sake of its sheer historical elegance) while somehow escaping the censure of his friends—and now Sussis and Boggs were toying with one possible solution. "Donald had me up to his workshop," Boggs explained, "and he was showing me the way

TOP:
Portrait of Benjamin Franklin on the old U.S. hundred-dollar bill

BOTTOM:
Portrait of Benjamin Franklin on the new U.S. hundred-dollar bill

fur coats are fashioned. I'd really had no idea the extent of the craft involved. What on the outside looks like one continuous pelt, on the inside gets revealed as hundreds, literally hundreds of thin strips of fur meticulously sewn together in such a way that the grain and the sheen of the exterior pelts seem to flow naturally together. And the pattern of those sewn-together overlaps is itself incredibly beautiful—the sheer craft of it!—so that I've been thinking of having Donald make me up an inside-out coat. That way I could sort of hide the fur itself from my politically correct friends—anyway, I've always loved the feel of fur against skin—and at the same time I'd be able to show off those incredible, intricate patterns. They're really something. They almost remind me of the meticulous cross-hatching you find, say, in the portrait of Franklin on the face of a $100 dollar bill."

Times being what they are, Sussis was tiring of the fur wars and indeed for some years had been phasing himself out of the fur business altogether. At age fifty, he'd gone back to school and retooled himself as an expert on electronic money, of all things. "Not that big a stretch," both of them now concurred. "Remember that mink from Lithuania," Boggs offered. "Or the way old U.S. paper bills included on their backs those graphic renderings of the actual silver coins for which they could be redeemed. Well, look at this." He began rifling through his wallet. "Up on the Upper West Side, Citibank has an experimental program going where they're trying to get merchants and customers to dispense with ordinary money altogether and instead use cards like this"—he pulled one out—"with little electronic chips embedded in the plastic, designed to keep track of transactions as they occur: sort of like Metro cards. If, for instance, the chip currently registers fifty dollars and you make a purchase of thirty-seven dollars, swiping your card through the shopkeeper's machine, your card will subsequently register as 'containing' thirteen dollars, until, that is, you replenish it at one of the bank's machines. But the thing is, people apparently have been balking at using the cards, so what Citibank has been doing, to ease them along conceptually, I suppose, is—see, look at the pic-

ture they have on the face of the card." A photo of a wad of paper money.[1]

Citibank cash card (1988) depicting the sorts of money for which it's supposed to entice replacement

Sussis pointed out that soon the desktops on people's personal computers would likewise feature cashbox-type icons, filled up with, say, fifty dollars which could be spent on impulse Internet purchases (and then replenished via a modem link to the bank), without having to go through all the current rigmarole of entering credit card numbers and passwords and so forth—in other words exactly as with ordinary money, except that no actual

1. In the end, Citibank's efforts at graphic reinforcement proved futile—at least for the time being. The money imagery notwithstanding, most West Siders evaded the bank's blandishments and declined the moneycard's many highly vaunted advantages. (The litany of reasons advanced by hesitant consumers and shopkeepers sounded like a reprise of some of those Boggs and I had encountered on our own moneywalk several years earlier: shopkeepers outside the West Side wouldn't honor the cards; laundry machines and pay phones couldn't process them; the cards seemed too conceptually foreign, too time-consuming, too complicated. In the end, people still weren't quite willing to trust or credit them.) In early November 1998, Citibank suspended the trial program. (See piece on the front page of the Business Section, *New York Times*, November 4, 1998.)

money (or, anyway, no physical) money would ever change hands. (There is, of course, one other potential difference which theorists on the subject are currently worrying through —the fact that paper money is anonymous, for better or worse, whereas digital money may not necessarily be.) The vast majority of the world's money flow these days, as Sussis pointed out (he'd been contributing articles on the subject to the *Wall Street Journal*'s on-line service) is digital in any case—electronic blips and bits relentlessly sloshing back and forth across the ether. A recent article in *Time* magazine (April 27, 1998) had quoted the head of some management consulting firm to the effect that "in the electronic city, the final step in the evolution of money is being taken. Money is being demonetized. Money is being eliminated." To which Sussis asserted his full agreement—hence in part, the piquancy of his interest in the almost doubly superannuated transaction he and Boggs had spent the afternoon contemplating.[2]

And yet, not so fast. For all the seeming imminence of its demise, money—paper money, actual, physical money—was still plainly capable of exerting its myriad mystifications. Consider the situation of those poor Indonesians who—admittedly due in part to a lethal undertow brought on by those nanosecond hypersurges of international electronic investment and disinvestment—had woken up one fine morning to find their rupiah bills (their actual money, their physical money) suddenly worth 80 percent less than just a few weeks before. (I found myself wondering how many rupiah drawings, and in what denominations, it might now take to pur-

2. Of course, not everyone is as blithe about the hypercomputerized moneyless future. Elsewhere in the same *Time* article, an NYU economics professor voiced his concern about a world in which profit-driven banks were capable of and, indeed, almost compelled into marketing ever more risky and arcane financial instruments to ordinary customers. If, for instance, "you're using derivatives and you don't know what you're doing, there is a real danger. It's like letting a child play with a nuclear reactor." *Time* itself went on to note how "the China Syndrome aspect of all this interconnected finance is among its most worrisome features. What if the whole interconnected computer network crashes? (Hell, what if just your part does?)"]

chase a mink stole—and how that differed from what it would have taken just a few months ago.) Or consider the situation of Europeans over the next several years, who will be having to get used both to brand new, standardized continentwide currency, the Euro, and to all the everyday market disruptions (from the need for new cash registers to the devastations in traditional trading patterns) that the introduction of that currency and those standardizations is going to entail. In the Euro's case we have the further mystery of a denominated currency that is being introduced *first* in electronic digital form (for interbank transactions), as of January 1999, in anticipation of its eventual arrival as a physical entity (paper money one will actually be able to fold into one's wallet) three years further down the line. Boggs and Sussis contemplated such conundra for a while before moving on to another curiosity of the current interface between the old and new money technologies: the problem the Secret Service was suddenly having with counterfeiters deploying computers tied to laser printers.

Another recent article, this one in the *New York Times* (March 12, 1998), had pointed out how would-be counterfeiters no longer had to erect elaborate, noisy, conspicuous, and relatively easily trackable printing operations, generating bales of bogus bills which then had to be hoarded in storage while the counterfeiters gradually eked them into circulation (difficult-to-hide hoards which in turn, once uncovered, in themselves could provide crucially damning evidence in a court of law). Nowadays, deploying the sort of personal computers and color ink-jet printers commonly found in millions of American homes, counterfeiters were capable of generating marginally adequate bogus bills one at a time, on a need-to-use basis—affording currency agents none of the sorts of investigative targets that used to be central to their work, and prosecutors little of the evidence crucial to their sentencing intentions (since the seriousness of the charge traditionally depended on the size of the cache seized). The article portrayed agents and prosecutors with their hands completely full trying to deal with the resultant chaos. "Evidently not full

enough," quipped Boggs, when Sussis and I summarized the piece for him. "I mean, they still seem to have plenty of time to lavish on the likes of me."

Sussis had to be getting back to work (his laptop, that is, not his workshop), so he called over a waiter to settle his part of the bill. While we were waiting for the change, Boggs recalled an evening a while back at a fancy restaurant where he'd run up a sizable tab, settling it ("I was off the meter") with a conventional, ordinary one-hundred dollar bill, at which point the waiter had returned with a drawing of his change. How, we wondered, had Boggs reacted? "I accepted it ecstatically!" he crowed.

After Sussis left, Boggs went on regaling me with more of his art-and-money world adventures. To date, he figures, he's spent well in excess of a million dollars' worth of his own drawings, and the transaction pieces in which they've resulted continue to compound handsomely in value on the secondary market, fetching upward of $100,000. His work has been acquired by institutions ranging from the British Museum to the Art Institute of Chicago, the Museum of Modern Art, and the Smithsonian, which eventually acquired the Sebel Town House transaction. (That piece, in turn, was prominently featured in a show organized by the Smithsonian, entitled "The Realm of the Coin: Money in Contemporary Art," which traveled throughout the United States between 1992 and 1994, such that one wing of the federal government found itself celebrating Boggs's achievement at the very moment that another wing seemed to be gearing up to indict that very same achievement.)

Meanwhile Boggs was consistently feted in numismatic circles as well. When he surfaced at coin conventions, he was regularly hounded for autographs. "I've developed a policy," he recounts. "People ask for my autograph and I say, 'Okay, autographs are one dollar, signatures are one hundred dollars. Which would you like? That generally stumps them. But as it happens, I sign my name two different ways, so I can make it work. At one autograph convention I attended a while back, my signature was on prominent display at one booth, and I

had a friend go over and inquire as to its price: Two hundred dollars! The next day it was gone, and the dealer, who'd in the meantime found out about my presence at the fair, sought me out and offered to buy one hundred signatures at $100 each. 'Naah,' I told him, 'that's not how I operate. Just one per customer.' For that matter, there's developed this weird market in my ordinary bank checks—it's gotten to be like with Picasso: people simply don't cash them. To date, over $2,000 worth of them have simply not cleared the bank. At one booth at another money convention, one of my checks, for $69, was on sale for $325. 'You think you can sell this?' I asked the guy. 'This is my third one,' he replied."

Perhaps not surprisingly, the IRS has gotten wind of all these shenanigans and, entirely independently of the Secret Service, has taken an increasing interest in Boggs's exploits. In 1995 they subjected him, as he puts it, "to a full-blown, analyze-you-down-to-your-hair-follicles audit," after which, he says, the agent in charge pulled him aside to confide, "You're the cleanest thing we've ever seen. You know, you really don't have to keep receipts for seven cents."

Not that everything has gone so smoothly. Boggs's erstwhile dealer, Vrej Baghoomian, went bankrupt in 1992, stiffing him for $89,000 as he hightailed it out of the country (it developed, astonishingly, that he'd allegedly been managing a lively side-market in counterfeit Basquiats as well). Boggs himself was likewise plagued by a proliferation of artists who'd taken to forging his money drawings—in fact, there was even a collector in Chicago who'd started specializing in bogus Boggs notes! (Boggs was trying to figure out if there was some way he could get in on the deal: which is to say, was it possible to forge oneself?)

And what, I asked him, had become of his Pittsburgh project? "Ach," he said, "that one finally didn't go very far—the Secret Service managed to smother it, more or less. Not so much by continuing to harass me personally as by blanketing the city—going to dealers, collectors, merchants, in print and over the airwaves—putting the fear of God into everyone that passing or even just accepting those bills could subject them

all to the direst of consequences. That pretty much put the kibosh on the whole scheme. For that matter, since then they've been threatening dealers and collectors and museums all over, to my considerable detriment."

I was struck by the paradox of Boggs's situation. Granted, Boggs may well have lost thousands of dollars in sales and transactions owing to the fear of merchants and collectors at the prospect of run-ins with the Secret Service. But by the same token, Boggs's rising worth in the market is clearly a direct function of his transgressive approach and the persecution it invariably provokes. Boggs has often said he'd have stopped by himself a long time ago if only the government hadn't been so insistently trying to stop him—which may be true, as far as it goes. On the other hand, he's the kind of guy who'd probably just keep pushing (he once told me of another swell idea: a series of paintings with marijuana mixed into the pigment), who'd keep inching ever deeper into suspect terrain until the government finally did move to stop him.

But then again, maybe not. I mentioned to Boggs my idea about his work and its Zenonian component, and he smiled before countering, "That's cheeky and funny, but I don't really see it that way. I mean, I do all this work that I don't show and can't show without appearing to concede the point, to be seen as running away in fear, and I couldn't live with that perception. I'm haunted by Harnett's betrayal. I mean, they confiscated his four paintings and then made him the same proposal they sometimes seem on the verge of making me: 'If you promise you won't do it anymore, we'll give you all your stuff back.' And he caved—I still can't get over it! To do so would be like saying, 'All right, you win, I'll be a zombie; now can I have my toys back?'"

He paused before continuing. "Harnett and Jim the Penman. I spend a lot of time thinking about both of them. I bought a Jim the Penman drawing a while back—a long story: part of a challenge, you know, to see who could draw better. The exercise made me understand what he was doing—passing those superb drawings as real money—and it made me

sick to my stomach. To be possessed of such surpassing skills and then to squander them like that. Disgusting. It literally turned my stomach." It was another of those strange moments with Boggs where, suddenly, things had unaccountably drifted from highest hilarity to utmost seriousness.

So, I asked him at length, what was going on between him and the feds?

Boggs heaved a vast sigh before launching out on the saga. "Let's see," he said. "Where were we? Well, you'll recall how back in December 1992, as I was preparing to launch my big Project, the Secret Service swooped down and busted me in Pittsburgh. Or, rather, they *didn't* bust me. They seized all my stuff—over thirteen hundred items, as an itemized inventory subsequently revealed: the bulk of my lifework—they threatened to bust me, darkly implying that they were seizing all that stuff as part of an investigation inexorably leading toward my arrest, and then, as the months passed, nothing happened. They suggested that they'd be back for more, and over the ensuing months they regularly threatened further raids, but, in the event, at least up till now, they haven't seized anything else. As I say, they regularly contact dealers, collectors, museum people, and others warning them all off my work, as if I had the plague. But they haven't busted me. On the other hand, nor have they returned my work."

In part owing to the considerable publicity generated around his plight, Boggs was able to secure the services of a high-powered young attorney, Kent Yalowitz, based in the Manhattan office of the blue chip New York/Washington, D.C., firm of Arnold & Porter. Together the two of them began by appealing directly to Lloyd Bentsen, the Treasury Secretary in the incoming Clinton administration—who proved singularly oblivious to their pleas. Time passed, nothing happened, and eventually, in September 1993, Yalowitz filed a civil suit on Boggs's behalf before the U.S. Circuit Court of Appeals for the District of Columbia Circuit. (To the extent that this had been the Secret Service's strategy all along, they'd now succeeded in getting Boggs to sue them in

civil court, rather than their having to go after him in criminal court—thereby, in the process, assuring adjudication before a judge rather than a jury.)

Yalowitz's plea on Boggs's behalf, argued before U.S. District Judge Royce Lamberth during two days of hearings later that fall, sought the return of his property and the suspension of all ongoing persecution. (As part of one of his initial filings, Yalowitz had included a full-scale reproduction of one of Boggs's drawings in his brief. "You can't do that!" an assistant U.S. attorney had sputtered. "It's against the law!" To which Yalowitz calmly replied, "Indict me." He left the reproduction of the drawing in the brief, and, needless to say, they didn't indict him.) Yalowitz's argument essentially consisted of two prongs. Judge Lamberth was being asked, in the first instance, to declare once and for all that, in the absence of even any imputation of Boggs's intent to defraud, his work as such was self-evidently not in violation of any law. Short of that, Judge Lamberth was being asked to order the government in effect to put up or shut up: either to bring a criminal case against Boggs, in which he could openly defend himself before a jury of his peers, or else to cease its open-ended persecution of the artist and return his property forthwith.

In the event, in December 1993, Judge Lamberth declined to rule altogether on the second prong of Yalowitz's petition, limiting himself to a forceful judgment in the Secret Service's favor regarding the first half of the Boggs claim: the law forbidding the making of "obligations" in the "similitude" of U.S. currency was fairly straightforward, in the judge's opinion; Boggs's work arguably fell well afoul of it, such that the government could go on proceeding in any manner it saw fit. Declaratory relief denied.

Yalowitz and Boggs now appealed Judge Lamberth's ruling to the U.S. Circuit Court of Appeals, sitting in Washington, D.C. "We drew a pretty interesting three-judge panel," Boggs recounted. "Doug Ginsburg—remember that guy who got bounced from a Supreme Court nomination because he had smoked marijuana with some of his students at Harvard? James Buckley, the former senator and brother of Bill. And a

guy named David Tatel, who—I swear to God—happens to be stone blind! Which seems a bit odd in a case like this, but there you go." Boggs and Yalowitz appealed both prongs of their case, and it took two years before they achieved half a judgment: in October 1995, in a short order without any elaborate explanation, the Circuit Court affirmed Judge Lamberth's ruling in the first instance and declined to rule for the time being regarding their second line of argument, throwing that part of the case back to Judge Lamberth's chambers for further adjudication.

It took almost another two years before that part of the case received a proper hearing. "And it was a really strange scene," as Boggs now recalled for me. "And quite tough, let me tell you, for me to sit calmly through. Essentially the lawyers were arguing over whether my drawings were more like pornography or more like hard-core drugs. If they were more like pornography, which is what Kent was arguing, then we were dealing with a question of censorship versus free expression, and it ought to be up to a jury of my peers to make the final determination. But the government was countering that my bills were more like hard-core drugs, contraband and evil in and of themselves, and hence subject to seizure without recourse. I mean, obviously a heroin pusher, for instance, can't demand the return of his stash on property grounds, even if the government decides not to prosecute the case. In the end, the judge, who again sided with the government, declared that, as far as he was concerned, what my drawings were most like—and this really blew my mind—was *kiddie* porn, so manifestly evil and obviously self-evident when you came upon it, that you didn't need a jury to make any further determination. Which, of course, is ironic since, in the meantime—this was October 1997—that big Barnes and Noble/Sally Mann/Jock Sturges case has erupted around precisely that issue, and that case will be going before a jury."

In any case, Boggs and Yalowitz now appealed that ruling back to the three-member Appeals Court panel. I asked Boggs how much all this was costing and how he was affording it. "So far," he said, "my own legal bills have come to al-

most $800,000. I was mentioning that figure to one of the Secret Service guys at the most recent hearing—crazy thing is that on a personal level I have all sorts of friends on their side—and he said, 'You think that's something; our side has easily spent five times that!'

"But anyway, I realized that I would have to come up with something special in this regard, so a while back I contacted Thomas Raymond Hipschen, the chief master engraver with the Bureau of Engraving and Printing in Washington. He's the incredible artist who's created the engravings for the Franklin on the new hundred-dollar bill—the one without the fur—the Grant on the new fifty-dollar bill, and the Jackson on the new twenty. And I made him a proposal, which he accepted. For starters, I offered him my last $1,000 "Project: Pittsburgh" Boggs bill as a down payment for a steel-engraved portrait of me, actual money scale. Which he proceeded to do and, I think you'll agree"—Boggs leaned over conspiratorially, gazed from side to side and then pulled a sample impression out of his satchel—"did quite handsomely. And I've now made eight impressions of this engraving as the basis for eight one-hundred-thousand dollar bill drawings. That's how I intend to pay—and assuming that Arnold & Porter can work out any complications with their tax people (and, as ever, there's no reason why they can't offer the IRS their fair cut), that's how I intend to go on paying."

Boggs smiled slyly. I had a sudden realization that no matter how the appellate court ruled, the loser was likely to go on appealing, and appealing the appeals, and then mounting fresh challenges, and on and on, ad infinitum—like Zeno never, never ever, quite reaching his target—since this was that peculiarly hilarious nightmare of a case in which both sides were in a position to cover and go on covering all their costs simply by printing fresh money.

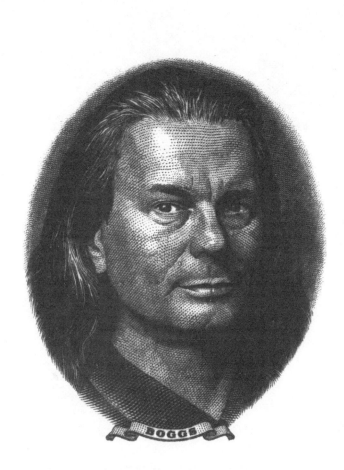

Thomas Raymond Hipschen,
master engraving of J. S. G. Boggs
(1998)

J. S. G. Boggs, *Monumental Lanscape* (1993)

BIBLIOGRAPHIC ESSAY

"GOLD IS THE SOUL of all civil life, that can resolve all things into itself and turn itself into all things," noted one Samuel Butler in his *Prose Observations: 1660–1680*. In much the same vein, his contemporary John Selden (in *Table Talk*) observed, "Money makes men laugh."

The literature on money, at any rate, is vast, profound, all-encompassing, occasionally stupefying, and by turns harrowing and hilarious.

— —

A good place to start is with Georg Simmel's magisterial *The Philosophy of Money* (translated by Tom Bottomore and David Frisby; Routledge, 1978 & 1990), originally published in 1900, the same year as Freud's *Interpretation of Dreams*. For that matter, of course, Freud and Marx both have much to say on the protean, confounding nature of money ("All fixed, fast-frozen relations, with their train of ancient and venerable prejudices, are swept away, all new-formed ones become anti-quated before they can ossify, all that is solid melts into air . . . ," as the latter famously characterized money's latest incarnation in his *Communist Manifesto* of 1848). One of the most evocative contemporary attempts to bring the thinking of these two great masters into alignment is Norman O. Brown's 1959 *Life Against Death: The Psychoanalytic Meaning of History* (2d ed., Wesleyan University Press, 1985, with an introduction by

Christopher Lasch), particularly its fifteenth chapter, "Filthy Lucre" (with its subheads: Rationality and Irrationality, Sacred and Secular, Utility and Uselessness, Owe and Ought, Time Is Money, Giving and Taking, The City Sublime, Immorality, The Human Body, and Excrement). In a similar mode, Lewis Hyde offers *The Gift: Imagination and the Erotic Life of Property* (Vintage, 1983); and, more recently, a volume with particular relevance to the career of our current protagonist, *Trickster Makes the World: Mischief, Myth, and Art* (Farrar, Straus & Giroux, 1998). The fifth chapter, "Currency," of Mark C. Taylor's *Disfiguring: Art, Architecture, Religion* (University of Chicago Press, 1992) launches its readers out on an exhilarating conceptual ride, a veritable romp past all sorts of highly evocative signposts (including, for example, Walter Benjamin's passionate call for "a descriptive analysis of bank notes [whose] unlimited satirical force . . . would be equaled only by its objectivity. For nowhere more naively than in those documents does capitalism display itself in solemn earnest. The innocent cupids frolicking about the numbers, the goddesses holding tablets of the law, the stalwart heroes sheathing their swords before monetary units, are a world of their own: ornamenting the facade of hell.") Considerably more abstruse, though likewise flecked with aphoristic brilliance, is Jacques Derrida's meditation on a text by Baudelaire, *Given Time: I. Counterfeit Money* (translated by Peggy Kamuf, University of Chicago Press, 1992), with such chapters as "The Madness of Economic Reason," "The Poetics of Tobacco," and "Gift and Countergift, Excuse and Forgiveness." Somewhat more pragmatically relevant to Mr. Boggs's concerns is Charles W. Smith's *Auctions: The Social Construction of Value* (University of California Press, 1989). Two of the more recent contributions along these general and speculative lines are novelist and former *Financial Times* correspondent James Buchan's *Frozen Desire: The Meaning of Money* (Farrar, Straus & Giroux, 1997); and editor Kevin Jackson's *Oxford Book of Money* (Oxford University Press, 1995).

Turning to the history of money, a good place to begin is with Jonathan Williams's marvelously illustrated *Money: A*

History (St. Martin's Press, 1997), issued in conjunction with the opening of the British Museum's Money Gallery. A perhaps more wryly urbane overview is afforded by John Kenneth Galbraith's *Money: Whence It Came, Where It Went* (Houghton Mifflin, 1975); along with his *A Short History of Financial Euphoria* (Whittle Books, 1990; reprinted by Penguin in 1994). From an obverse (though equally crisp) monetarist perspective, there's Milton Friedman's *Money Mischief: Episodes in Monetary History* (Harvest, 1991); or, earlier, his *Monetary History of the United States: 1867–1960* (coauthored with Anna Jacobson Schwartz; Princeton University Press, 1963).

Some of the oldest, strangest, and most "primitive" and far-flung forms of exchange (everything from cowrie shells to elephant tails) are catalogued in Charles J. Opitz's definitive illustrated monograph, *Odd and Curious Money, Descriptions and Values* (2d ed., First Impressions Printing, Ocala, Fla., 1991). (For a particularly diverting side trip here, delve into the 1995 novel *Enigma Variations*, by academics Richard and Sally Price. Published by the Harvard University Press, this disconcerting shape-shifter of a narrative explores such issues as authenticity and counterfeiture against the backdrop of academic anthropology and the so-called "primitive art" trade.)

The Early Modern transition is masterfully surveyed in Fernand Braudel's 1979 *The Structures of Everyday Life: The Limits of the Possible* (the first volume of his *Civilization and Capitalism: 15th–18th Century*, translated by Siân Reynolds, Harper & Row Perennial Library, 1985), especially in the seventh chapter, "Money." A more focused case study, covering some of the same terrain a bit earlier on is provided in Ann Wroe's *A Fool and His Money: Life in a Partitioned Town in Fourteenth-Century France* (Hill & Wang, 1995).

The astonishing Tulipmania craze that swept the Netherlands in 1636–37 is elegantly anatomized in Simon Schama's *The Embarrassment of Riches: An Interpretation of Dutch Culture in the Golden Age* (Knopf, 1987); it also provides one of the key case studies, along with the Mississippi Scheme and the South Sea Bubble, in Charles Mackay's classic 1841 *Extraordinary Popular Delusions and the Madness of Crowds* (Crown Reprint,

1995). An abridged version of the latter work is included alongside a complete rendition of *Confusión de Confusiones*, the remarkable 1688 discourse of Josef de la Vega, a bewildered Portuguese Jewish businessman and poet resident in Amsterdam, in a recent edition compiled by Martin Fridson for Wiley Marketplace Books (1996). A thoroughly engrossing, if somewhat quirky, exploration of the fateful introduction of an especially rapacious money economy into North America across the seventeenth century forms one of the principal themes of Jerry Martien's *Shell Game: A True Account of Beads and Money in North America* (Mercury House, 1996; with an introduction by Gary Snyder).

The history, more specifically, of paper money receives a thorough survey in *As Good as Gold: Three Hundred Years of British Banknote Design*, an illustrated catalog by V. H. Hewitt and J. M. Keyworth (British Museum, 1987). For parallel coverage of this side of the Atlantic, consult *Paper Money of the United States: Illustrated Guide with Valuations*, compiled by Robert Friedberg (Coin & Currency Institute, Clifton, N.J.; 11th ed., 1986) or the sumptuous auction catalog *Important Early American Banknotes 1810–1874, from the Archives of the American Bank Note Company* (Christie's, New York, September 1990). A succinct account of the nineteenth-century Populist critique of gold, silver, and greenbacks is provided in the first chapter of Lawrence Goodwyn's *The Populist Moment: A Short History of the Agrarian Revolt in America* (Oxford University Press, 1978). A more literarily focused account of the same material is found in Walter Benn Michaels's *The Gold Standard and the Logic of Naturalism: American Literature at the Turn of the Century* (University of California Press, 1987), from which it's just a short conceptual jaunt over to an intriguing little pamphlet of Gertrude Stein's, *Selected Notes on Money (Excerpts from "Money" and "All About Money")* (Stewart, Tabori & Chang, New York, 1989).

As for the future of money in the information age, consult James A. Dorn's *The Future of Money in the Information Age* (Cato Institute, 1997); or Elinor Harris Solomon's *Virtual Money: Understanding the Power and Risks of Money's High-Speed*

Journey into Electronic Space (Oxford University Press, 1997). The furrier-turned-cybernaut Donald Sussis's writings include a long, unpublished manuscript, "Money in the Age of Information," as well as such regular contributions to the *Wall Street Journal*'s interactive edition as "E-Money's Pioneers Have Found Cyberspace an Unforgiving Land" (August 9, 1997).

When it comes to the intertwining histories of art and money, the gold standard, at least in English, has now probably been set by Mark Schell in his copiously illustrated *Art and Money* (University of Chicago Press, 1995), which, incidentally also includes an exceptionally generous bibliography on the subject. Jürgen Harten and Horst Kurnitzky earlier trawled similar waters in their 1978 show, "Museum des Geldes: Uber die Seltsame Natur des Geldes in Kunst, Wissenschaft und Leben," the exceptionally useful two-volume catalog of which was published by the Städtische Kunsthalle in Düsseldorf. Another version of the same show the following year at the Centre Pompidou in Paris, under the name "Musée des sacrifices, Musée de l'argent: De la nature étrange de l'argent dans l'art, la société, et la vie," yielded a condensed single-volume French-language version of the same catalog.

The peculiarly American late-nineteenth-century intertwining of painting and money received a lovely exposition in the *Old Money: American Trompe l'Oeil Images of Currency* catalog to a 1988 show at the Berry Hill Galleries in New York, with an essay by Bruce Chambers. Also consider Alfred Frankenstein's *After the Hunt: William Harnett and Other American Still Life Painters, 1870–1900* (University of California Press, 1975). The Corcoran curator Edward Nygren's essay "The Almighty Dollar: Money as a Theme in American Painting" eventually appeared in the Summer-Autumn 1988 issue of *Winterthur Portfolio*.

More recent cross-border raids between the territories of money and art are documented in the richly illustrated catalog to the Smithsonian Museum's traveling "The Realm of the Coin: Money in Contemporary Art" show (curated by Barbara Coller; 1992–94, at various venues, including Hofstra

Museum in Hemsptead, N.Y., and including works by Boggs). In 1995, Sharon Poggenpohl guest-edited a special *Money!* issue of *Visible Language*, a journal out of the Rhode Island School of Design, which included an interview with Boggs. Not particularly easy to find, but well worth the effort, are the intricately argued artist's chapbooks of Miles DeCoster, including *Money* (Nexus Press, Atlanta, 1984); and *Infallible Counterfeit Detector/Iconomics* 2.74 (Artists Book Works, Chicago, 1988). For obvious reasons, Lucy Lippard's classic *Six Years: The Dematerialization of the Art Object from 1966 to 1972* (reissued by the University of California Press in 1997) deserves scrutiny by those interested in the recent prehistory of Boggs's endeavor, as does Arthur C. Danto's seminal treatise, *The Transfiguration of the Commonplace: A Philosophy of Art* (Harvard University Press, 1981). Of the other individual artists mentioned in my own brief survey, Hans Haacke has provided the occasion for several especially interesting survey monographs, notably including *Framing and Being Framed* (Press of the Nova Scotia College of Art and Design, Halifax, in conjunction with NYU Press, 1975); and *Unfinished Business* (New Museum of New York and MIT Press, 1986).

As for Boggs himself, to date his most complete illustrated catalog (with essays by Bruce Chambers and Arthur C. Danto) was published (minus certain crucially suppressed images) in 1990, in conjunction with his "Smart Money/Hard Currency" traveling show, organized by the Tampa Museum of Art. (The catalog includes a bibliography on the artist, complete up to that date, including his own "Art under Arrest" piece in the October 1987 issue of *Art and Antiques*.) Philip Haas's *Money Man* film documentary aired over the BBC in 1991–92 and then enjoyed a brief commercial run as well. Doubtlessly the most supple exploration of the legal issues involved in Boggs's case is to be found in his lawyer Kent Yalowitz's two-volume *Brief for the Appellant* (J. S. G. Boggs vs. Robert Rubin et al., U.S. Court of Appeals for the District of Columbia Circuit, May 18, 1998). Those desiring to keep up with developments both in the case and in the rest of the

artist's career are invited to consult (naturally) Boggs's Web site: <http://jsgboggs.com>.

As for some of the work's wider, more ominous implications, see the op-ed piece by James Grant, the editor of "Grant's Interest Rate Observer," in the *New York Times* of June 19, 1998. Under the headline "Every Currency Crumbles," Grant begins, "Currencies, being made of paper, are highly flammable." He goes on to suggest that

people with even a little bit of money ought to be asking what it's made of. J. S. G. Boggs, an American artist, has made an important contribution to monetary theory with his lifelike paintings of dollar bills . . . The Secret Service has investigated him for counterfeiting. "All money is art," Mr. Boggs has responded.

After surveying the history of repeated monetary conflagrations, up through the then-current Asian meltdown, Grant concludes, "Naturally, officials and editorialists are now calling for even better fire prevention systems. But 'stability,' the goal sought after, is ever unattainable. The history of currencies is unambiguous. The law is, Ashes to ashes and dust to dust."

J. S. G. Boggs, *The Aged Cloth of Culture* (1994)

INDEX

PICTURE CREDITS

PAGES i, viii–ix, 2–3, 7, 13, 19, 72–73, 77, 83, 112, 118–19,
128, 129, 130, 132, 135, 145, 146, 154: Courtesy J. S. G.
Boggs.

PAGE 25: Courtesy Corbis.

PAGE 27: From the back cover of Charles Opitz, *Odd and Curi-
ous Money* (Ocala, Fla.: First Impressions Printing, 1991).

PAGES 41, 43, 49: © 1999 Artists Rights Society (ARS), New
York/ADAGP Paris.

PAGE 45: © Elke Walford, Hamburg, Hamburger Kunsthalle.

PAGE 46: Barton Lidice Benes, mixed media with currency,
1986, collection of Mr. Thomas McNemar, Lexington,
VA.

PAGE 48: Courtesy Andre Emmerich Gallery.

PAGES 84–85: '43-74-5, William Michael Harnett, *Still Life—
Five Dollar Bill*, 1877, Philadelphia Museum of Art, Alex
Simpson, Jr., Collection.

PAGE 88: Courtesy Berry-Hill Galleries, New York City.

PAGE 89: Victor Dubreuil, *Safe Money*, 1896, 30.25 x 76.8, oil
on canvas, in the collection of the Corcoran Gallery of Art,
Washington, D.C. Museum purchase through a gift from
the heirs of George E. Lemon, 1980.65.

PAGE 117: Robert O'Dea/Arcaid, 4153:30:1. Image is reversed.